POSTCARD HISTORY SERIES

Indian River County

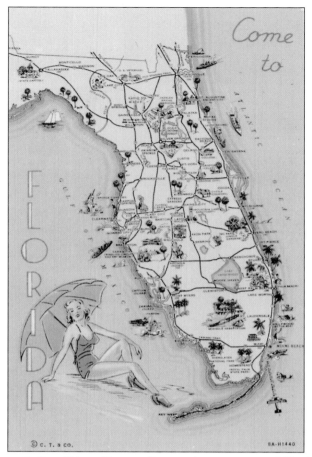

COME TO FLORIDA. Indian River County lies on the east coast of Florida. Look for Vero Beach and McKee Jungle Gardens, a little northeast of Lake Okeechobee, on this *c.* 1940s map. Vero Beach is in the southern half of the county. The following pages provide more detail about some of the interesting history of the area. (Published by Genuine Curteich-Chicago "C. T. Art-Colortone"; courtesy Indian River Historical Society Collection.)

ON THE FRONT COVER: The Driftwood Resort of today on Ocean Drive is a renowned establishment with villas, a pool, and Waldo's Restaurant. The Driftwood Inn featured on this postcard was originally built in 1935 by Waldo Sexton as an oceanside retreat for his family, but soon he opened it to others. The original inn had only two rental rooms and a dining room and kitchen. In keeping with its name, the inn was built from an eclectic mix of items that drifted to the beach or were salvaged by Sexton from old Palm Beach mansions. Over the years, it continued to grow, assembled from an astounding admixture of items collected by Sexton from around the world. It is listed in the National Register of Historic Places. (Published by Curt Teich; courtesy Bruce J. Smith Collection.)

ON THE BACK COVER: These letters show scenes typical of the county in the first half of the 20th century. Tourists and home seekers were lured to this area with visions of living or vacationing in a tranquil, tropical paradise where it was simple to prosper and enjoy life with easy travel via the railroad. Lush exotic foliage, palm trees, orange groves, and water vistas typified this ideal. (Published by Orange News Company; courtesy Bruce J. Smith Collection.)

POSTCARD HISTORY SERIES

Indian River County

Indian River Genealogical Society

ARCADIA
PUBLISHING

Published by Arcadia Publishing
Charleston SC, Chicago IL, Portsmouth NH, San Francisco CA

Printed in the United States of America

Library of Congress Catalog Card Number: 2007920921

For all general information contact Arcadia Publishing at:
Telephone 843-853-2070
Fax 843-853-0044
E-mail sales@arcadiapublishing.com
For customer service and orders:
Toll-Free 1-888-313-2665

Visit us on the Internet at www.arcadiapublishing.com

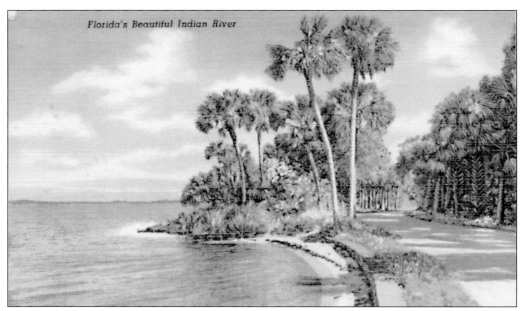

FLORIDA'S BEAUTIFUL INDIAN RIVER. Promoters resorted to poetry on their postcards to lure residents:

> Florida.
> Fruits and flowers and balmy breezes,
> Winter gardens everywhere;
> Lovely homes and groves and palm trees,
> Every day the best of fare.

(Published by Genuine Curteich-Chicago "C. T. Art Colortone"; courtesy Indian River Historical Society Collection.)

CONTENTS

ACKNOWLEDGMENTS

We would like to thank the following individuals and institutions for their assistance in the making of this book: the Postcard Book Committee, with Chairman Ellen Stanley and committee members Margaret Bell, Suzy Bromwell, Cindy Davis, Nancy Garvey, Tom Garvey, Patty Mayell, Pat Rand, and Tony Young; Pam Cooper; Alma Lee Loy; Jeannette Shack; and Archive Center, Indian River County Main Library. Postcards used are from Bruce J. Smith, Professional Association; Indian River County Historical Society; Walter A. Siewert Collection; Ray Mack Collection; C. A. Vandiveer Collection; Elisabeth Green Dane; Scott Chisolm; Mel Fisher Museum; Mark P. Wygonik; the Vero Beach Hibiscus Festival Committee; and the Archive Center, Indian River County Main Library. Without the help of all mentioned, this book would not have been possible.

KEY FOR POSTCARD SOURCE INFORMATION:

AC	Archive Center, Indian River County Main Library (AC IRCML)
CHI	Scott Chisolm's personal collection
DAN	Elisabeth Green Dane's personal collection
HS	Indian River County Historical Society Collection, AC IRCML
MF	Mel Fisher Museum
MAC	Ray Mack Collection, AC IRCML
SMI	Bruce J. Smith, P.A., Collection
SIE	Walter A. Siewert Collection, AC IRCML
VAN	C. A. Vandiveer Collection, AC IRCML

INTRODUCTION

Indian River County is a jewel located on Florida's east coast that continues to be discovered and enjoyed—first by nomadic Native Americans, later by seekers of opportunity, and now by families, retirees, seasonal residents, and tourists for its natural beauty, semitropical climate, and relaxed lifestyle. The county is named for the Indian River Lagoon, a sizeable body of water that separates the barrier island from the mainland.

In the early years of Florida's history, Indian River County was a part of other counties: St. John's County from 1821 to 1824; Mosquito County from 1824 to 1844; Santa Lucia County from 1844 to 1855; Brevard County from 1855 to 1905; and St. Lucie County from 1905 to 1925.

In the 1800s, the area was vast wetlands, teeming with a wide variety of wildlife, mosquitoes, and lush semitropical growth, nearly impassable by land. The Second Seminole War (1837–1842) resulted in the building of Fort Vinton and roads and trails through the county. By the end of the Civil War, homesteaders began to arrive. In 1874, the first House of Refuge on the east coast of Florida was built in present-day Vero Beach at Bethel Creek. The 1880s saw the beginning of real estate speculation, the building of the railroads, and the cultivation of citrus, pineapples, and beans. Henry Flagler brought the railroad to Sebastian in 1893. The fishing industry grew because of the abundance of fish in the Indian River Lagoon.

The first three decades of the 20th century was the first boom period of the county. Promoters from the North encouraged commercial industries and settlers by draining the swampland, dredging canals, and building demonstration farms. Construction revealed Paleo-Indian remains (Vero Man), which revolutionized the thinking of archeologists. In 1920, the second bridge to cross the Indian River Lagoon was built at Vero. More than 200 buildings were built between 1920 and 1927. Vero was renamed Vero Beach in 1925, six years after its incorporation. Banks failed from 1926 to 1928.

In the 1930s, the Indian River Citrus League promoted customer loyalty to the Indian River brand name. McKee Jungle Garden was opened by business partners Waldo Sexton and Arthur G. McKee. New Deal programs such as the Works Progress Administration built sidewalks, parks, streets, water and sewer lines, the county courthouse, and the community building. In 1932, the airport was built and Eastern Airlines established commercial air service.

In 1942, the airport was appropriated as a U.S. naval air training station, the community center became a servicemen's club, and the Casino and Windswept housed troops. The military brought in 2,700 men, 300 WAVES (Women Accepted for Volunteer Emergency Service), and 250 airplanes. In 1948, the Brooklyn Dodgers made Vero Beach their spring training camp. Holman Stadium and Dodgertown were built.

The county saw growth of the tourist industry in the 1950s. After the war, servicemen returned with their families to make their homes here in Indian River County. Tourists came by car to both mom-and-pop motels and luxurious hotels that sprang up all over town. The Treasure Coast became a favorite vacation destination. Frozen orange juice revolutionized the citrus industry. In 1951, the first Merrill Barber Bridge was built over Indian River Lagoon. In 1957, Piper Aircraft built a manufacturing plant.

Indian River County is part of the Treasure Coast, which was named for the many wrecked treasure galleons that carried gold, silver, and jewels back to Spain. Gold coins still wash up on local beaches. Eighty years after the incorporation of Indian River County, 130,000 residents continue to treasure their beautiful home.

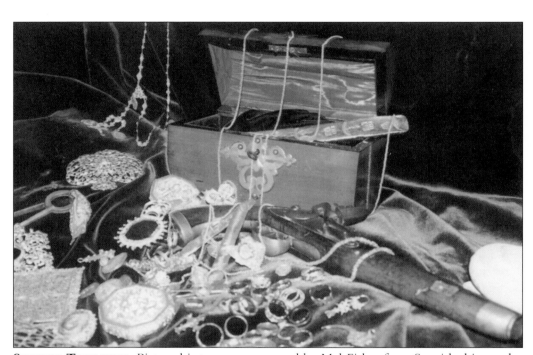

SPANISH TREASURE. Pictured is treasure recovered by Mel Fisher from Spanish shipwrecks. In 1715, a flotilla of Spanish merchant ships foundered off the central Florida coast. Fifteen hundred survivors from the wrecks gathered in the vicinity of the Sebastian Inlet, where the Spanish later set up a salvage operation and temporary settlement to recover the gold and silver cargo. They were able to reclaim only a fraction of the shipments. That area of the survivors' camp near Sebastian Inlet is listed in the National Register of Historic Places. (Courtesy MF.)

One

RIVERS, RAILS, AND SETTLERS (1800s–1910)

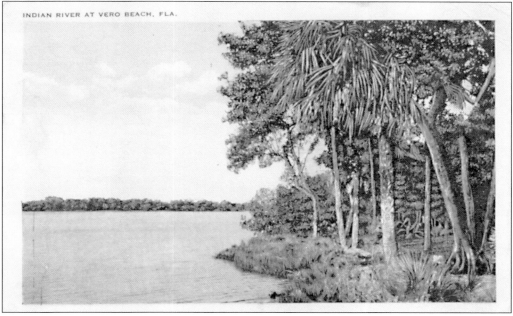

INDIAN RIVER AT VERO BEACH, FLA.

INDIAN RIVER LAGOON. During the period from 1800 to the 1910s, the Indian River area was a jungle-like marshland alive with an incredible variety of wildlife. The Indian River is actually a lagoon, with many shifting inlets from the ocean. It is separated from the Atlantic Ocean by several barrier islands and is the most extensive barrier island/tidal inlet system in the country. Originally called the Rio de Ays after the first inhabitants of the area, the Ais tribe, the name was later changed to the Indian River. The river flows approximately 156 miles and is up to 5 miles wide. It is very shallow and only the dredging for the Intracoastal Waterway allows the passage of large boats. The financial impact of the Indian River Lagoon is immense; boating, fishing, tourism, and water sports, as well as real estate ventures, provide billions of dollars to the local economies. Until the advent of the railroads, the river was the only means to access what is now Indian River County. (Published by Tichnor Quality Views; courtesy SMI.)

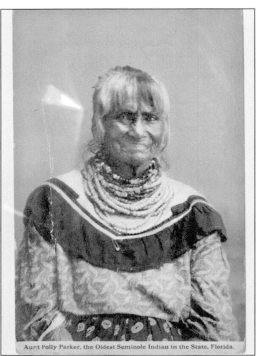

Aunt Polly Parker, the Oldest Seminole Indian in the State, Florida.

AUNT POLLY PARKER. The Seminole pictured in this 1917 postcard was thought to be the oldest Native American in the state of Florida. Born in 1826, she was over 90 when she died. She lived west of Wabasso for many years and was a guest at the table of Charles Gifford, a farmer and the son of pioneer Henry Gifford, and his wife. (Published by the Cochrane Company; courtesy HS.)

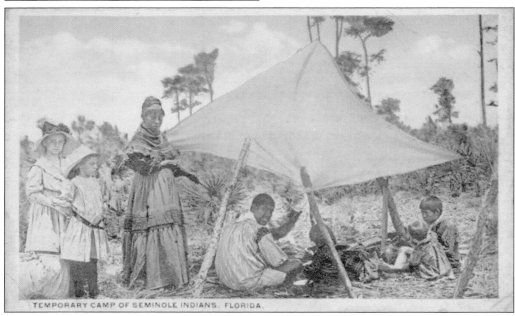

TEMPORARY CAMP OF SEMINOLE INDIANS. FLORIDA.

SEMINOLE INDIANS. The word Seminole is thought to be a corruption of the Spanish word *Cimarron*, meaning runaway. As control of Florida passed from Spain to England, back to Spain, and finally to the United States, Florida became a haven for runaway slaves, Creek Indians, and related tribes. By 1821, when Florida became a territory of the United States, there were approximately 5,000 Native Americans living in the peninsula's interior under the new tribal designation *Seminole*. (Courtesy MAC.)

Tom Tiger. Tom Tiger was a renowned chief of the Florida Seminoles in the late 1800s. His tribe spent part of each year in the Indian River County area on Tiger Hammock. The Seminoles planted corn and pumpkins in the spring and returned in the fall to harvest their crop. This property was sold and became part of the Indian River Farms Company land. Farms Company tomatoes grown there were shipped north carrying the Tiger brand. (Published by Cochrane's Book Store; courtesy HS.)

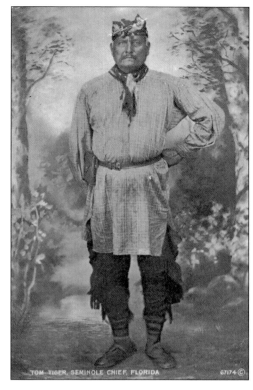

Indian River Citrus. Since the late 1800s, this area has been growing Indian River–brand citrus. The best of this fruit was once grown on the barrier islands such as Orchid, where the combination of salt air, a high water table, heavy rainfall, and nutritious soil produced sweet fruit with thin skin and 15 to 20 percent higher juice content than citrus grown in more arid sections. (Published by Elite Postcard Company; courtesy SMI.)

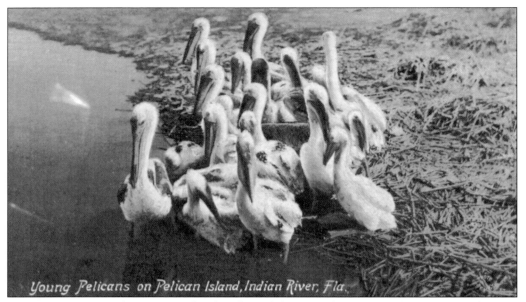

Young Pelicans on Pelican Island, Indian River, Fla.

PELICAN ISLAND. The German family of Gottlob Kroegel immigrated in 1872, settling on Barker's Bluff overlooking Pelican Island on the Indian River. Barker's Bluff was an ancient Ais Indian shell mound, which Gottlob sold to St. Lucie County in 1908 to create the first paved road between Stuart and Micco. Gottlob's son, Paul, was a boatbuilder and captain. Paul Kroegel is included on the Great Floridians 2000 list, a program instituted to honor individuals who have contributed significantly to the state's history. (Published by M. Mark; courtesy SMI.)

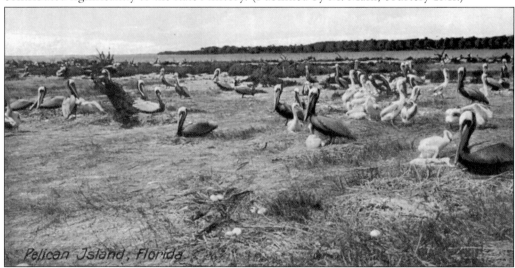

Pelican Island, Florida

FIRST WILDLIFE PRESERVE. Dr. Henry Bryant is thought to be the first ornithologist to visit Pelican Island, which he did in the 1850s, followed by many others from the 1880s to early 1900s. Due to the efforts of ornithologist Frank M. Chapman, the Audubon Society, and the American Ornithologist's Union, Pelican Island was established by Pres. Theodore Roosevelt as the first national wildlife refuge in the United States on March 14, 1903. Paul Kroegel was its first warden. It is listed in the National Register of Historic Places. (Published by Leighton and Valentine; courtesy SMI.)

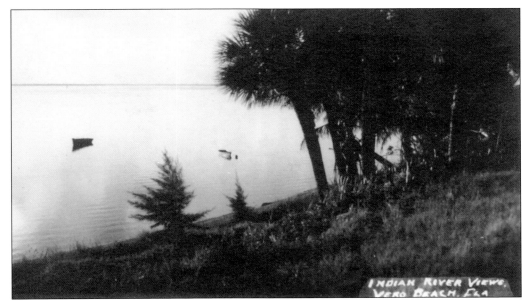

INDIAN RIVER VIEW. Steamboats were vital to the early development of the area, carrying passengers, freight, produce, and mail. The *Santa Lucia* came 3,000 miles down the Ohio and Mississippi Rivers, around Florida, and up the ocean to the inlet to serve the local traffic. The *Indian River* made a weekly trip from Titusville to Sebastian. Others were the *St. Lucie, Sweeney, Cinderella, St. Augustine,* and *Swan.* The era of the steamboats ended in 1894 because of railroad competition and freezes. (Courtesy SMI.)

CLARENCE A. VANDIVEER AND HIS MOTHER, LAURA GROBY VANDIVEER. Clarence A. Vandiveer moved from Miami to Wabasso in 1908, and by 1910, he had planted a citrus grove and built a two-story house. Active in local affairs, he and Rev. G. S. Owen published the *Mimeo News of Wabasso*, providing local and church news to post office–box holders from Grant to Winter Beach, as well as to 300 Northerners who visited Wabasso. (Courtesy VAN.)

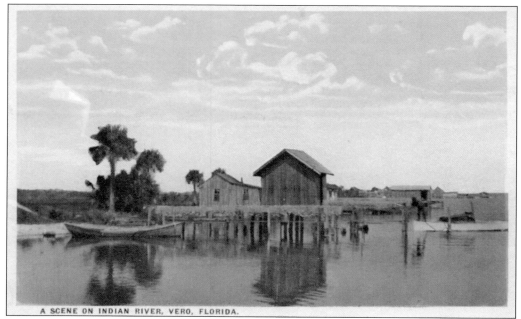

A SCENE ON INDIAN RIVER, VERO, FLORIDA.

INDIAN RIVER SCENE. The principal activities in the early 1900s were commercial fishing and pineapple growing. Fish camps were situated up and down the river. "Run boats" would collect fish from the camps each day and take them to the packing houses, where they were processed and packed with ice in wooden barrels for the trip north. (Published by Asheville Post Card Company; courtesy SMI.)

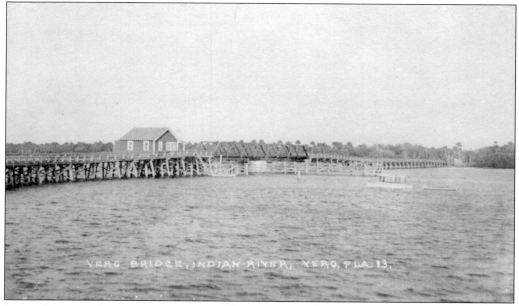

VERO BRIDGE, INDIAN RIVER, VERO, FLA. 13.

VERO BRIDGE, INDIAN RIVER. Early life centered on the Indian River. Early mail delivery was by riverboat. Floating stores, as many as five at one time, provided early settlers with necessities. News traveled by boat. Mail was also carried by boat before regular federal routes were established. Dr. F. H. Houghton offered his dental services by boat. (Courtesy HS.)

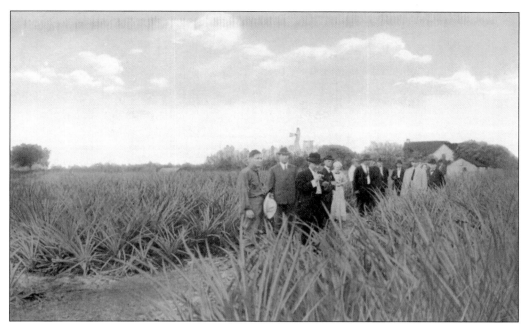

PINEAPPLE FIELD OF O. O. HELSETH. Ole Olson Helseth purchased a house and land on Crawford's Point in 1896. He became the first postmaster of the area, named Oslo by his wife as a tribute to Norway. He grew pineapples and citrus, later was county commissioner, and was a founding director of Farmers Bank of Vero. (Published by L. B. Kopp; courtesy SMI.)

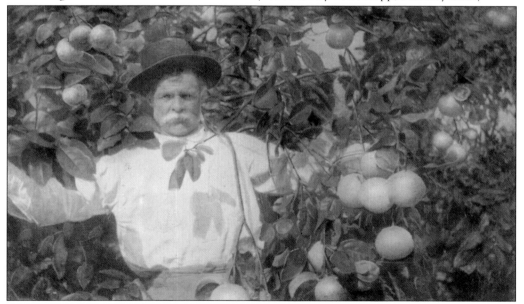

J. J. ROBERTS. J. J. Roberts moved to Vero around 1902 and purchased 20 acres, planting 8 acres of oranges and grapefruit. He purchased another 40 acres from Indian River Farms Company to establish another grove around 1914. Roberts is shown in his 8-acre grove, from which he received exceptional crop yields of 4,000 to 8,000 boxes. He enjoyed showing visitors through his groves. (Published by L. B. Kopp; courtesy SMI.)

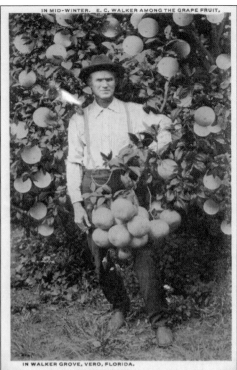

IN MID-WINTER. E. C. WALKER AMONG THE GRAPE FRUIT,

IN WALKER GROVE, VERO, FLORIDA.

ELI WALKER GROVE. E. C. Walker's grove was one of the earliest in Indian River County. He purchased a 10-acre grove west of Vero located on a rich hammock, "the Island," surrounded by water. Later the Indian River Farms Company grew up around him, and his grove became a showplace for its prospective buyers. By 1914, he owned 140 acres and had expanded his groves. (Published by C. T. American Art; courtesy SMI.)

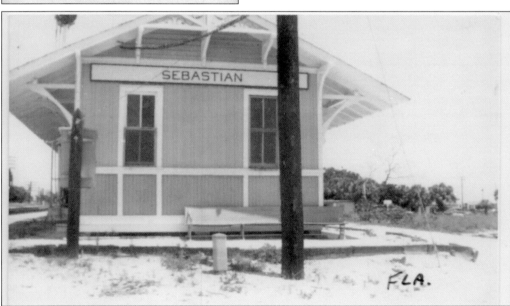

SEBASTIAN

FLA.

SEBASTIAN TRAIN DEPOT. The depot sat at the junction of the Florida East Coast Railroad and the Fellsmere Railroad in Sebastian. December 11, 1893, marked the arrival of the first train in Sebastian. At one point, a steam locomotive ran once a week between Sebastian and Fellsmere, and the rest of the week a specially equipped Model T Ford ran on the tracks between the two towns. (Courtesy SMI.)

Two

"IMPROVING" ON PARADISE (1910S)
FELLSMERE FARMS COMPANY AND INDIAN RIVER FARMS COMPANY

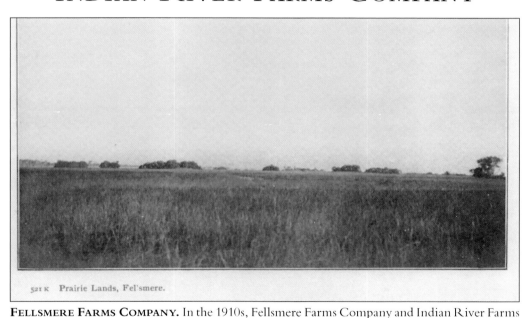

521 K Prairie Lands, Fel'smere.

FELLSMERE FARMS COMPANY. In the 1910s, Fellsmere Farms Company and Indian River Farms Company were the two land-development companies that provided the impetus to develop the Indian River County area. With dredging and draining, they turned a swampy marshland into acreage suitable for farming and homesteading. Vigorous promotion brought buyers by the trainloads; citrus groves, farms, and homesteads proliferated. Nelson Fell purchased 115,000 acres of land for speculation in 1910 and deeded it to Fellsmere Farms Company. In 1915, Fell became president of the company. Two communities were built, Fellsmere and Broadmoor, with hundreds of people settling there. The railroad was continued from Sebastian to Fellsmere. However, in 1915, flooding from a rainstorm caused Broadmoor to evacuate and Fellsmere began to decline. Bankruptcy resulted. (Published by the N.Y.N. Company; courtesy SIE.)

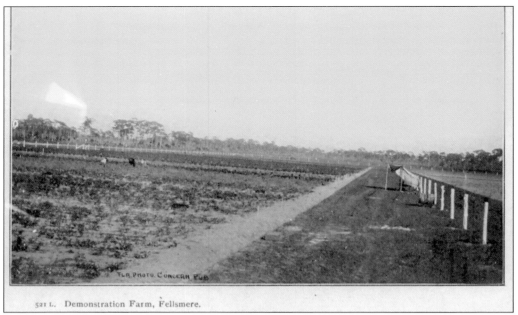

521 L. Demonstration Farm, Fellsmere.

DEMONSTRATION FARM. The Demonstration Farm of Fellsmere Farms Company, a showcase for prospective buyers, was the creation of Edward Nelson Fell, who was born in New Zealand in 1857 and was educated at Heidelberg University. He worked in mining for many years and was in Russia from 1902 until 1908. He utilized his mining experiences to reclaim the marshy Fellsmere lands. (Published by the N.Y.N. Company; courtesy SIE.)

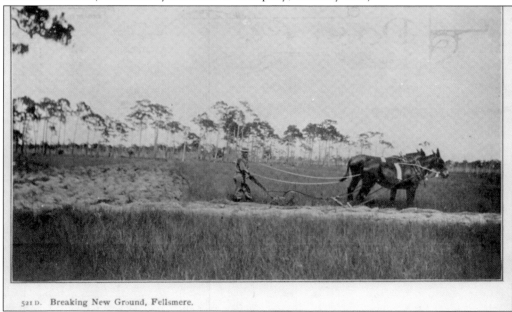

521 D. Breaking New Ground, Fellsmere.

BREAKING NEW GROUND. The quality of soil was so important to farmers that the Fellsmere Farms Company produced a pamphlet extolling the virtues of the muck soil on the properties it was selling, including the chemical analysis, types of crops it would support, and crop yield. (Courtesy SIE.)

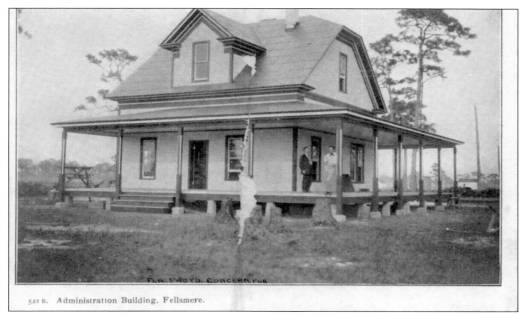

521 B. Administration Building. Fellsmere.

ADMINISTRATION BUILDING. Prospective buyers were brought from the Midwest by chartered train to Fellsmere and housed at the Fellsmere Farmhouse free for one week. They were taken by boat or horse-drawn wagons to inspect the property. In 1915, Fellsmere became the first incorporated city in what is now Indian River County. Broadmoor and Grassland were small neighboring communities that no longer exist. (Published by the N.Y.N. Company; courtesy SIE.)

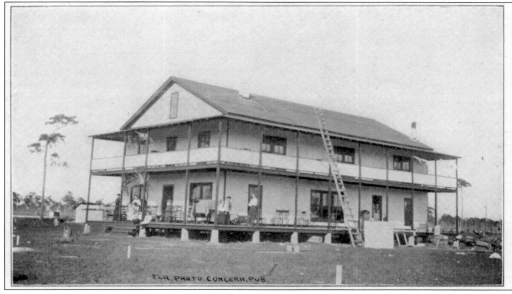

THE FELLSMERE INN. The Fellsmere Inn was a small, two-story building within two blocks of the Fellsmere Railway Station. H. C. Benjamin assumed management of the inn, and in February 1913, it was sold by Fellsmere Farms Company to Mr. and Mrs. A. C. Arnold of Sebastian. Its restaurant became a popular Sunday dinner spot for the whole county. The building is now an antiques shop. (Published by the N.Y.N. Company; courtesy SIE.)

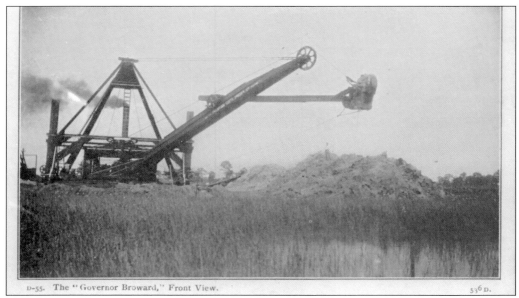

D-55. The "Governor Broward," Front View. 536 D.

THE *GOVERNOR BROWARD*. Gov. Napoleon Broward provided the impetus to populate marshy Florida and permit agricultural development, inducing the Florida Legislature to create a drainage district board and a method of levying taxes to fund the program in 1905. Broward had dredges built, including the *Governor Broward* (above), which was built in Chicago and arrived in Florida in April 1906, to carry out the reclamation process at Fellsmere Farms. (Published by the N.Y.N. Company; courtesy SIE.)

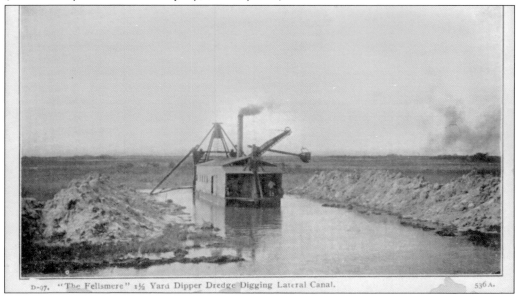

D-97. "The Fellsmere" 1½ Yard Dipper Dredge Digging Lateral Canal. 536 A.

THE *FELLSMERE*. A comprehensive network of canals and sub-canals was created with dredges to drain the land of Fellsmere Farms. Land reclamation, residential development, and expansion of agricultural operations depended on these extensive drainage projects. While these projects damaged the natural environment, they also encouraged growth. (Published by the N.Y.N. Company; courtesy SIE.)

20

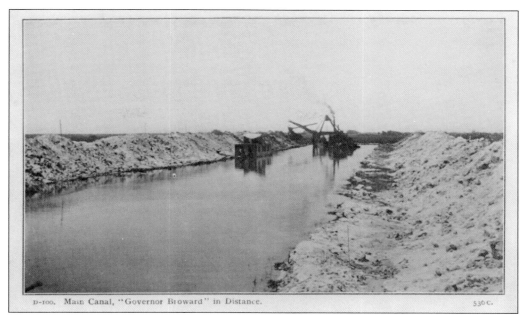

D-100. Main Canal, "Governor Broward" in Distance. 530 C.

CANALS. When the rains deluged the area in 1915, inadequate drainage, caused in part by lack of a dike to keep surrounding waters from draining into the area, flooded homes and fields in Fellsmere. The canals were overwhelmed, and entire area was flooded. The town of Broadmoor was washed away and abandoned. (Published by the N.Y.N. Company; courtesy SIE.)

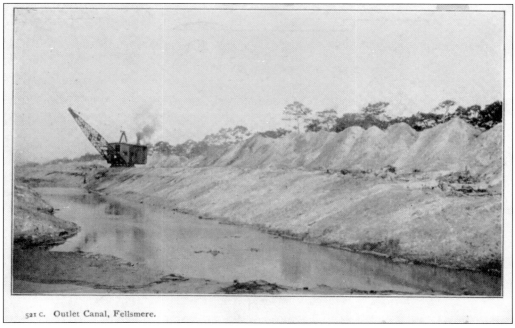

521 C. Outlet Canal, Fellsmere.

DREDGING TODAY. Many settlers left Fellsmere, and the town became dormant after 1915. Fellsmere survived as a town, however, and dredging projects continue today in that area, removing millions of cubic yards of muck released into the St. Sebastian River from outlet canals over the years. (Courtesy SIE.)

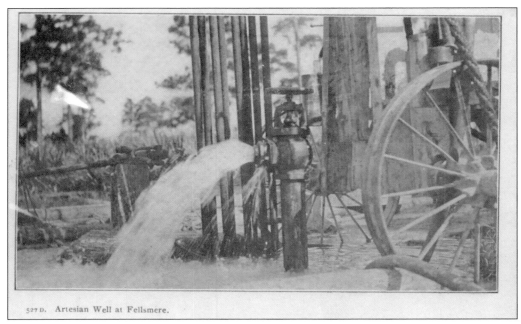

527 D. Artesian Well at Fellsmere.

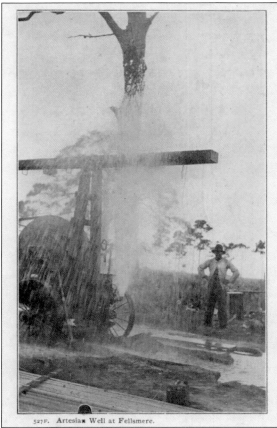

527 F. Artesian Well at Fellsmere.

ARTESIAN WELLS. The existence of underground artesian water was an important advertising point for the Fellsmere Farms Company, along with good farming land and warm weather. The company advertised that people need never go hungry or thirsty in Florida. Advertisements stated that their artesian wells produced water of exceptional purity. (Published by the N.Y.N. Company; courtesy SIE.)

WONDERFUL WATER. The first artesian well in Fellsmere was on Fellsmere Farms Company land, and by May 1912, more were in demand. A. J. Martel's well was drilled by Conkling Nursery Company in January 1913. (Published by the N.Y.N. Company; courtesy SIE.)

DIXIE HIGHWAY. Henry T. Gifford and S. T. Hughes built a road from Sebastian to Fort Pierce, the first Dixie Highway. They cleared a 10-foot-wide swath through palmetto and brush, measured the road, and set up painted mile markers from saplings. They were paid $22.50 per mile. (Courtesy SMI.)

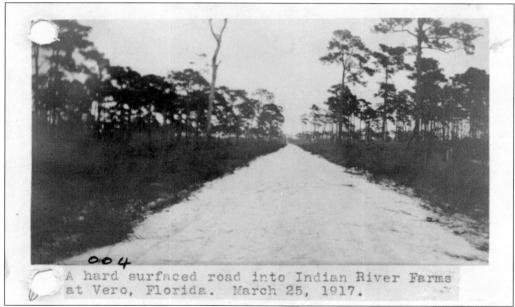

INDIAN RIVER FARMS COMPANY ROADS. In 1912, Herman Zeuch hired William H. Kimball, a civil engineer from Iowa, to survey and plan the drainage and building of roads for Indian River Farms. Zeuch selected names appropriate for Indian River County, giving Vero's early streets charming names such as Apache Road, Cherokee Avenue, Pueblo Drive, and Ute Pass. (Published by Commercial Photographic Company; courtesy HS.)

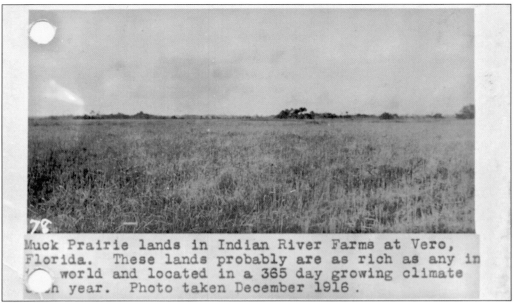

Muck Prairie lands in Indian River Farms at Vero, Florida. These lands probably are as rich as any in world and located in a 365 day growing climate year. Photo taken December 1916.

INDIAN RIVER FARMS COMPANY LAND. Herman Zeuch purchased 44,000 acres of land for the Indian River Farms Company, extending 12 miles along the Florida East Coast Railroad tracks past Quay and Gifford to the north of Vero and past Oslo to the south, and incorporated in 1912. Part of the land comprising Indian River Farms was Tiger Hammock, purchased from the Seminole Indian Tom Tiger. (Published by Commercial Photographic Company; courtesy HS.)

DRAINAGE CANALS. In 1913, Rogers Engineering and List and Gifford Construction began excavating for the series of canals and constructing the concrete spillway, moving 1.5 million cubic yards by 1915 for the Indian River Farms Company. During the digging, animal and human fossil remains were uncovered that dated back to 10,000 and 12,000 BC. Human remains, the subject of much anthropological controversy, were officially named "Vero Man." (Courtesy HS.)

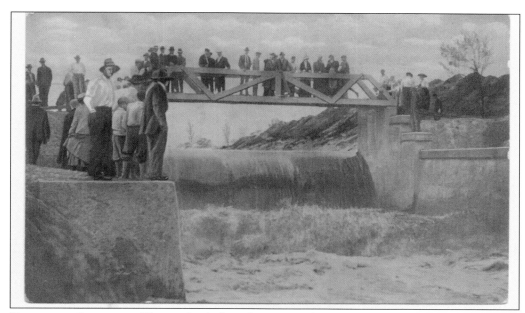

DRAINAGE SPILLWAY. The steel-reinforced concrete drainage spillway over the main canal was completed in 1913 for the Indian River Farms Company. It was constructed to allow for the 9-foot drop from the land level to that of the outlet of the Indian River. The temporary dam built to restrain the water flow during its construction was blown up during a widely attended ceremony opening the spillway. (Published by L. B. Kopp; courtesy SMI.)

ARTESIAN WELLS. Availability of potable water was an important feature of land sales for the Indian River Farms Company. Artesian wells drilled in the area were advertised as a "Fountain of Youth," good for rheumatism. In January 1914, the artesian well in Pocahontas Park was completed. Artesian wells were also dug around this time near the Sleepy Eye Lodge, on the Demonstration Farm, and at the Barber home. (Published by the Elite Post Card Company; courtesy SMI.)

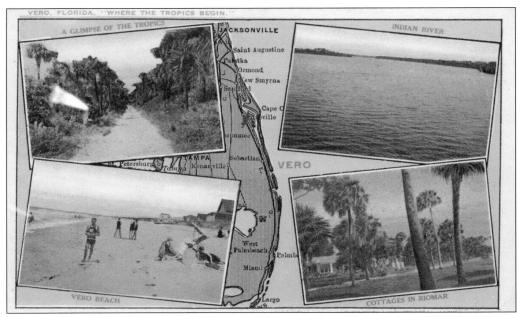

VERO, FLORIDA, "WHERE THE TROPICS BEGIN." The editor of the advertising journal *The Indian River Farmer*, Dr. J. L. Hutchison, was responsible for several popular advertising phrases: "You can look without buying but don't buy without looking," "From Zero to Vero," and "Where the Tropics Begin." He was also a vigorous promoter of the name "Indian River County." (Published by C. A. Stead; courtesy AC.)

CITRUS GROVE. The reverse of this promotional postcard reads: "In the Walker Grove in the center of Indian River Farms. Five-year old trees were laden with fruit almost to breaking point. Where on earth can You Buy Land which produces like this at Present Prices of Indian River Farms and on terms within the reach of all?" (Published by Elite Post Card Company; courtesy SMI.)

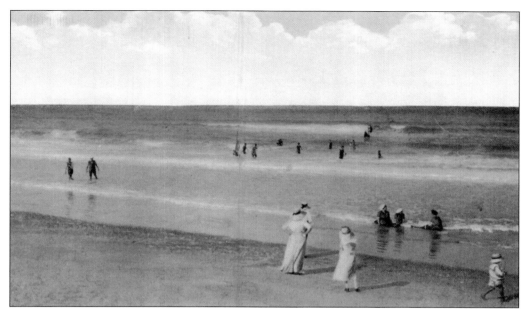

JANUARY SURF BATHING. Promotional postcards of swimmers at the beach in Vero in the winter were sent north by the Indian River Farms Company. In other mailings were articles about the benefits of life in Vero: there are 365 days a year of sunshine and balmy breezes; people live longer in Florida; financial independence is possible; four crops a year can be grown; and there are no hardships like the Western frontier. (Published by Elite Post Card Company; courtesy SMI.)

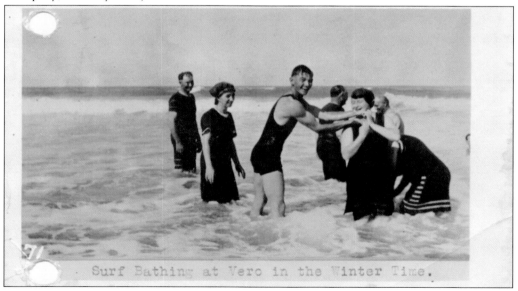

Surf Bathing at Vero in the Winter Time.

WINTER SURF BATHING. Pictured is more frolicking in the surf in the middle of winter to bring people to buy Indian River Farms Company land. Waldo Sexton wrote that one winter day when there was 12 inches of snow in Indianapolis, in Vero he helped a neighbor cultivate a farm, ate oranges from another neighbor's trees, and went for a refreshing swim in the ocean. (Published by Commercial Photographics; courtesy HS.)

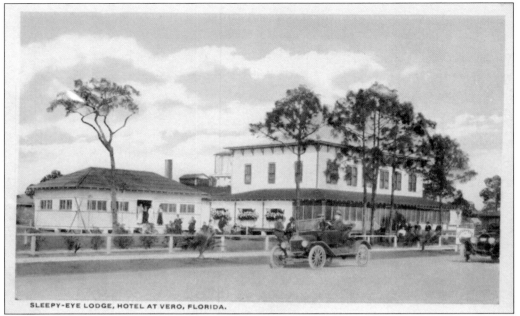

SLEEPY-EYE LODGE, HOTEL AT VERO, FLORIDA.

THE SLEEPY EYE LODGE. In 1912, a 24-room hotel was built by Hudson Baker to accommodate prospective buyers for the Indian River Farms Company. Herman Zeuch named it the Sleepy Eye Lodge in honor of Chief Sleepy Eye of Minnesota, who Zeuch said "never spilt a drop of blood of the white man." It had so many patrons that a Pullman car was parked to house the January 8, 1914, excursion of prospective buyers. (Published by C. T. American Art; courtesy SMI.)

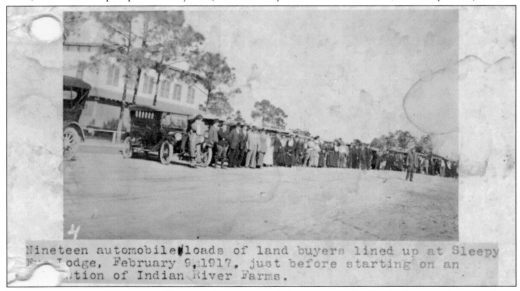

Nineteen automobile loads of land buyers lined up at Sleepy
Eye Lodge, February 9, 1917, just before starting on an
...tion of Indian River Farms.

EXCURSIONS TO WALKER GROVE. Excursions left on a regular basis from major northern cities to view the Demonstration Farm of Indian River Farms Company. Their lots were touted as "an ideal Christmas present." Nineteen automobile-loads of prospective buyers are lined up at the Sleepy Eye Lodge on February 9, 1917, waiting for their trip through Walker groves. (Published by Commercial Photographic; courtesy HS.)

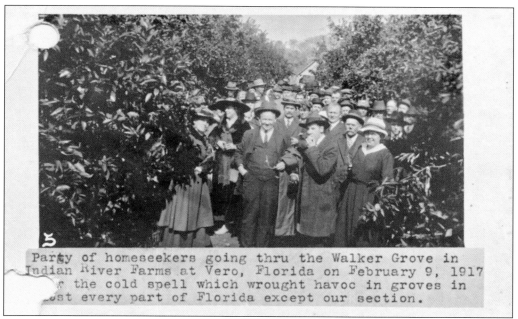

Party of homeseekers going thru the Walker Grove in Indian River Farms at Vero, Florida on February 9, 1917 _r the cold spell which wrought havoc in groves in _st every part of Florida except our section.

HOME SEEKERS IN WALKER GROVE. Shown is the February 9, 1917, excursion of home seekers going through the Walker Grove. Waldo Sexton was an enthusiastic spokesman for the Indian River Farms Company. He told the January 8, 1914, excursion that the land was so good that it shouldn't be wasted on roads and that subways should be put in, instead. (Published by Commercial Photographic; courtesy HS.)

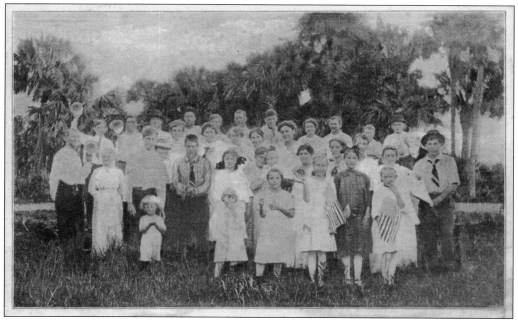

FOURTH OF JULY. This postcard advertises winter in July: "A happy Fourth of July crowd in Indian River Farms at Vero, Florida. They can also celebrate Christmas in the same way." (Courtesy HS.)

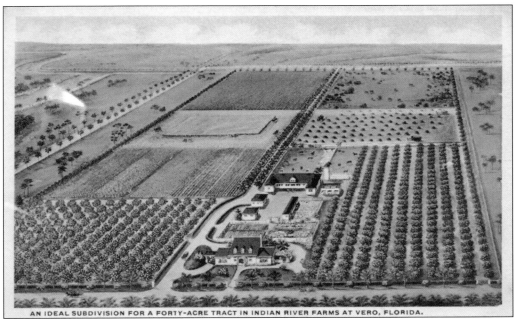

AN IDEAL SUBDIVISION FOR A FORTY-ACRE TRACT IN INDIAN RIVER FARMS AT VERO, FLORIDA.

AN IDEAL 40-ACRE FARM. This aerial view showing a lovely farm compound was used as an advertisement by the Indian River Farms Company to lure potential buyers to Vero. Information on the back of the card suggested that the land was suitable for growing a variety of fruits and vegetables, sugar cane, grain, and citrus. Fertile lands, drainage, irrigation systems, artesian wells, and roads were key selling points. (Published by C. T. American Art; courtesy SMI.)

DEMONSTRATION FARM. The Indian River Farms Company Demonstration Farm was a 10-acre plot planted to showcase the variety of crops that could be grown in the area. Experienced horticulturists managed the plot, served as an information source for purchasers, and became a central clearinghouse for local growers. They emphasized that three to four crops a year were possible. (Published by L. B. Kopp; courtesy SMI.)

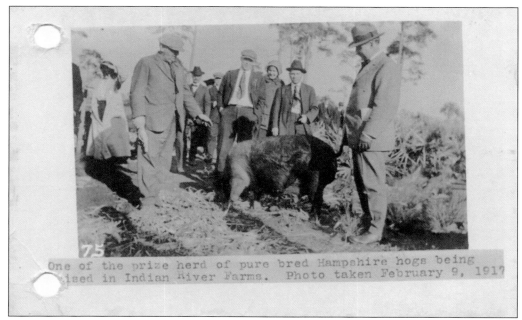

One of the prize herd of pure bred Hampshire hogs being ..ised in Indian River Farms. Photo taken February 9, 191?

ELI WALKER HOGS. In 1914, Eli Walker began raising hogs. Forty of his acres were planted in feed crops for the hogs, which were turned out into the fields to eat. The stock was bred from local razorbacks and full-blooded stock. The undesirable traits of the razorbacks were weeded out gradually to produce hogs of large size and weight adapted to local conditions. (Published by Commercial Photographic; courtesy HS.)

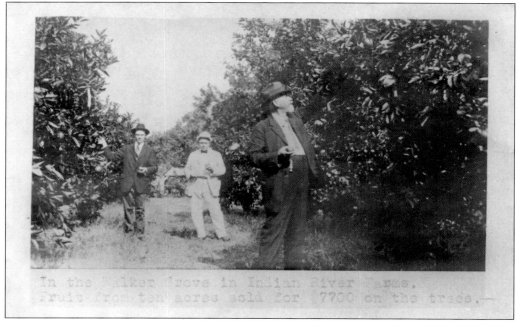

In the Walker Grove in Indian River Farms. Fruit from ten acres sold for $7700 on the trees.—

ELI WALKER GROVES. Purchasers are pricing fruit in the Eli Walker citrus groves. Ten acres of his fruit sold for $7,700 on the tree. (Courtesy MAC.)

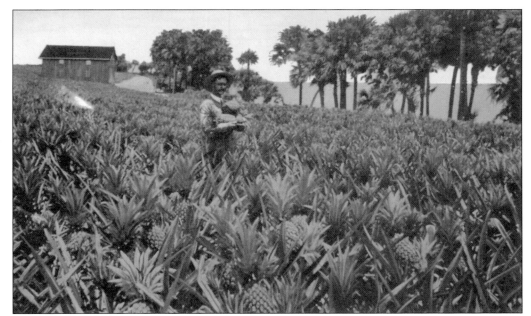

THE PINEAPPLE INDUSTRY. It was advertised by the Indian River Farms Company that pineapples could be harvested in only 18 months from the planting of slips. Pineapples grew well in poor soil with commercial fertilizers; however, they were very labor intensive and problems abounded. By 1917, pineapple cultivation had ceased. (Published by the Elite Post Card Company; courtesy SMI.)

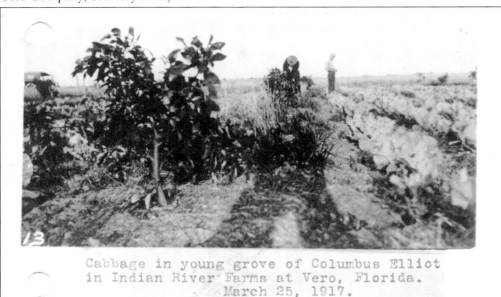

Cabbage in young grove of Columbus Elliot
in Indian River Farms at Vero, Florida.
March 25, 1917.

COLUMBUS ELLIOTT. This card displays a young citrus grove owned by Columbus Elliott in March 1917. Alongside the grove is a healthy-looking plot of cabbages. His property was originally part of Indian River Farms. (Published by Commercial Photographic Company; courtesy HS.)

WINTER VEGETABLES. An article in 1915 pointed out that fresh vegetables in winter could no longer be considered a luxury item. The states of Florida and California had changed the eating habits of the nation. This was particularly true of the Vero area's tomatoes and cucumbers that were shipped north. (Courtesy HS.)

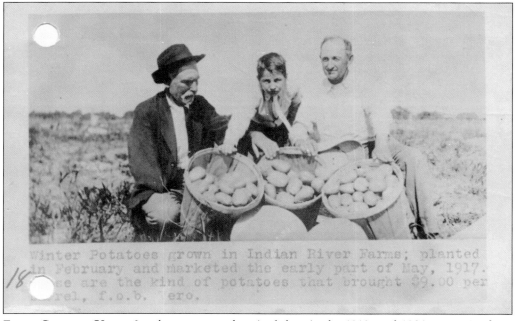

Winter Potatoes grown in Indian River Farms; planted in February and marketed the early part of May, 1917. These are the kind of potatoes that brought $9.00 per barrel, f.o.b. Vero.

FOUR CROPS A YEAR. Land promoters advertised that, in the 1910s and 1920s, statistics from the United States Department of Agriculture indicated that the average yield on an acre of Florida land was $110 as opposed to an average of $15 per acre for Northern farms. As many as four crops a year were planted by these early farmers for fast income. (Courtesy HS.)

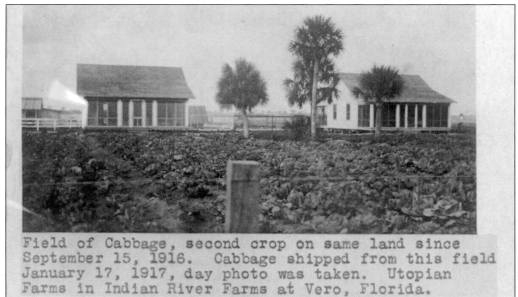

Field of Cabbage, second crop on same land since September 15, 1916. Cabbage shipped from this field January 17, 1917, day photo was taken. Utopian Farms in Indian River Farms at Vero, Florida.

UTOPIAN FARMS DEVELOPMENT PROJECT. Utopian Farms Development Project consisted of 1,200 acres purchased from Indian River Farms Company in 1915. In addition to citrus, Utopian Farms successfully cultivated a variety of vegetables. The importance and value of producing more than one crop a year was continually emphasized, as it is on this postcard of Utopian Farms cabbages. (Courtesy MAC.)

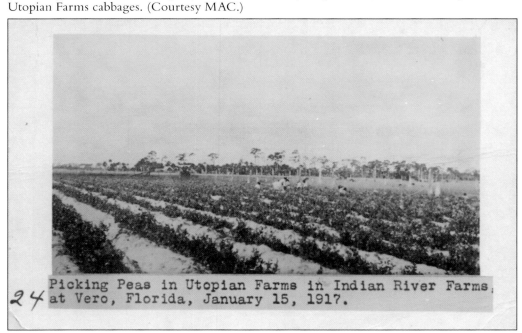

Picking Peas in Utopian Farms in Indian River Farms, at Vero, Florida, January 15, 1917.

UTOPIAN FARMS DEVELOPMENT PROJECT—PICKING PEAS. "America Must Feed Europe" was the headline of an article in 1914. It emphasized the importance of American agriculture, as postwar soldiers would be involved in repairing war damage, not farming. (Published by Commercial Photographic Company; courtesy AC.)

Three

HARD WORK AND GROWTH (1910s)

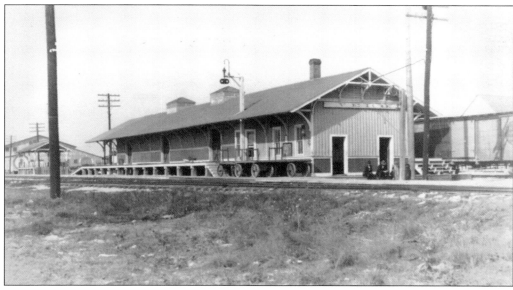

VERO TRAIN DEPOT. In the 1910s, the railroad brought settlers from the North and Midwest who utilized their skills to farm the land and open small businesses. Many hardworking, enterprising individuals bought 40 or 100 acres of land to plant citrus groves and raise agricultural crops, then to open a small store and tend to civic duties. The area grew steadily. Trains in the first decade of the 20th century had been in the practice of declaring the first and third Tuesday of each month Home Seeker Day, reducing the rates for those traveling with the intention of relocating in Florida. The flood of prospective buyers became so great that for January and February 1914, this was reduced to one day a month in order to alleviate congestion. The Vero Train Depot now houses the Indian River Historical Society and is listed in the National Register of Historic Places. (Courtesy HS.)

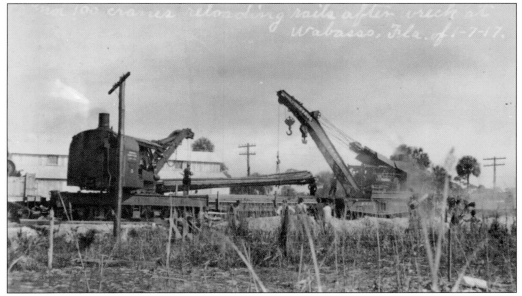

TRAIN WRECK AT WABASSO. One hundred cranes reloaded rails on the train after its wreck in Wabasso in 1917. By the early 1900s, Florida had 429 railroad companies chartered, of which 110 were operating. Half of the rails were controlled by three companies: the Florida Central and Peninsular Railroad; the Savannah, Florida, and Western; and the Florida East Coast Railway. (Published by Florida Photographic; courtesy VAN.)

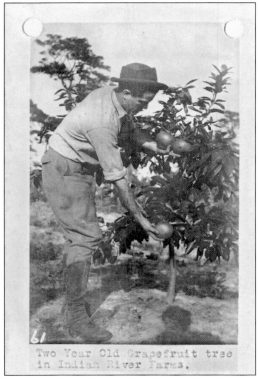

Two Year Old Grapefruit tree in Indian River Farms.

GRAPEFRUIT TREE. Serving the area's citrus groves, the Oslo Packing House (now Oslo Citrus Growers Association) is the oldest packinghouse on the East Coast, in continuous operation since 1920. This plant was a first step in making this region a major citrus exporter. Commencing in 1920, railroad cars full of citrus carried daily shipments to New York and Chicago. The plant was expanded and modernized in 1993. (Published by Commercial Photographic Company; courtesy HS.)

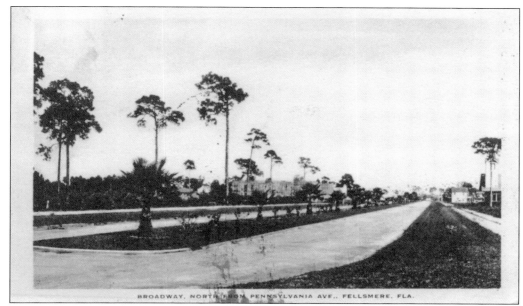

BROADWAY, NORTH FROM PENNSYLVANIA AVE., FELLSMERE, FLA.

FELLSMERE ENTERTAINMENT. Early entertainment in Fellsmere included the Dixie Playhouse, a baseball park and team, and a horseracing track east of town. Marion Fell provided a building for the library. The Library Association and drama club provided readings, concerts, and performances. A brass band performed. There was a tennis club and golf course as well. (Published by Frank X. Oliver, Hotel Fellsmere; courtesy SMI.)

WOMAN'S UNITY CLUB, VERO. Irene Young, wife of A. W. Young, the first Vero mayor, helped organize the Woman's Unity Club (later renamed the Woman's Club), which met originally at the Sleepy Eye Lodge. Land was donated by the Indian River Farms Company to erect the Woman's Unity Club building adjacent to the Youngs' house in 1916. The club was responsible for many beautification and civic projects, adopting the slogan "A beautiful Vero and surrounding country, the best place on earth to live." (Courtesy SMI.)

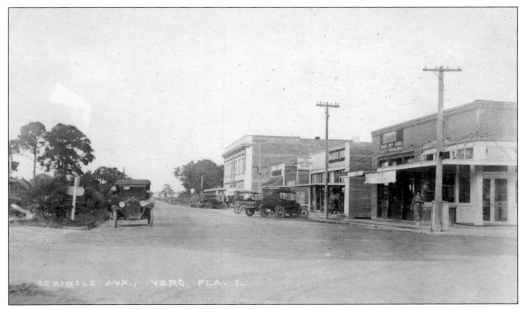

SEMINOLE AVENUE, VERO. The Indian River Farms Company's Herman Zeuch hired civil engineers William H. Kimball and Robert D. Carter to survey and lay out plans for the town of Vero "with an eye single to modern development and improvement." Seminole Avenue and Osceola Boulevard were at its center. Electric power came to a hotel and some offices in 1917 with the installation of a power plant. (Published by Eastern Illustrating Company; courtesy HS.)

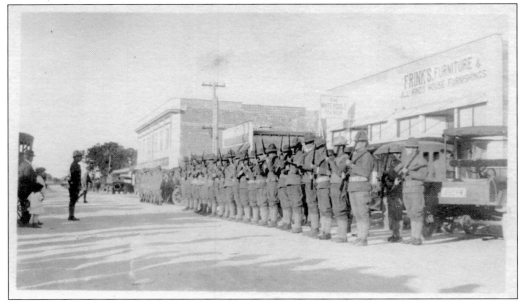

HOME GUARD, WORLD WAR I, VERO. The Home Guard was formed to handle local problems that might arise from World War I. Residents volunteered or were recruited and were trained and drilled in uniform with rifles. They are shown here on Seminole Avenue in downtown Vero in 1916. (Courtesy HS.)

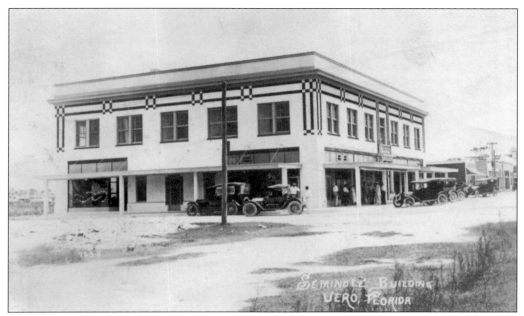

SEMINOLE BUILDING, VERO. Erected in 1918 by the Seminole Building Corporation, the Seminole Building was located at the corner of Seminole Avenue (Fourteenth Avenue) and Twenty-first Street. In 1922, it was purchased by Indian River Farms Company, and in 1939, realtor Forrest Graves bought it. Still in existence, it has housed many diverse tenants over the years and is now owned by Robert Brackett. (Courtesy HS.)

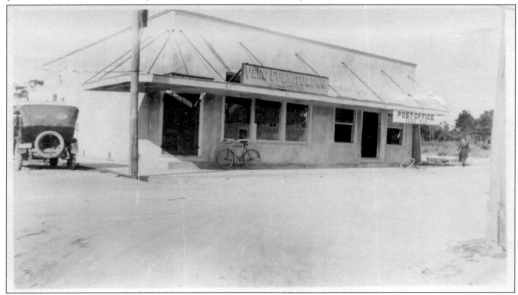

VERO FURNITURE COMPANY AND POST OFFICE. Clinton and Irene Routh were proprietors of Vero Furniture Company, located on Twentieth Street. It opened soon after November 15, 1925. In 1928, the post office was in this building on Twentieth Street when Frank W. Rodenberg became postmaster. Prior to then, it had been in the Henry Gifford home, the James Knight store on Commerce Avenue, and on Dixie Avenue. (Courtesy HS.)

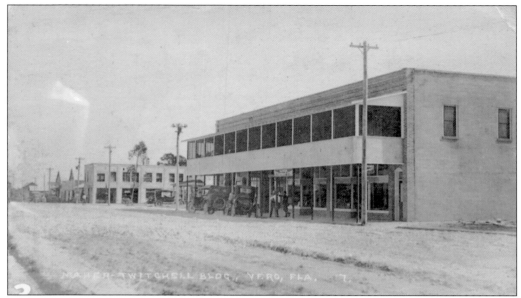

MAHER-TWITCHELL BUILDING, VERO. Sharon E. Twitchell and family arrived in Vero around 1912, purchasing 22 acres west of Vero for citrus groves on the site later occupied by Piper Aircraft. On Osceola Boulevard, he erected the first commercial building in Vero, Twitchell's Place, which advertised that it offered "everything": billiards, baths, barber shop, and, on the second floor, rooms to rent. (Published by Eastern Illustrating Company; courtesy HS.)

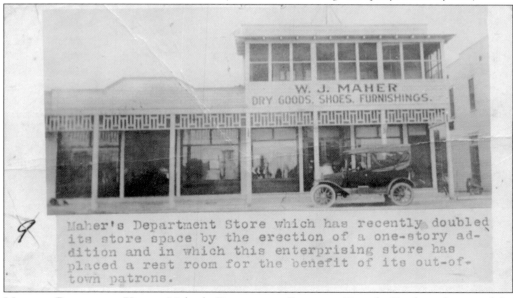

W. J. MAHER
DRY GOODS, SHOES, FURNISHINGS.

Maher's Department Store which has recently doubled its store space by the erection of a one-story addition and in which this enterprising store has placed a rest room for the benefit of its out-of-town patrons.

MAHER BUILDING, VERO. Maher's Department Store on Osceola Boulevard, owned by William and Catherine Maher, offered apparel at "pleasing prices." When it burned to the ground in November 1919, very little was saved, but no lives were lost. Maher went immediately to St. Louis to purchase new stock. The structure was rebuilt shortly thereafter in brick and concrete on the original site. It is listed in the National Register of Historic Places. (Published by Commercial Photographic Company; courtesy HS.)

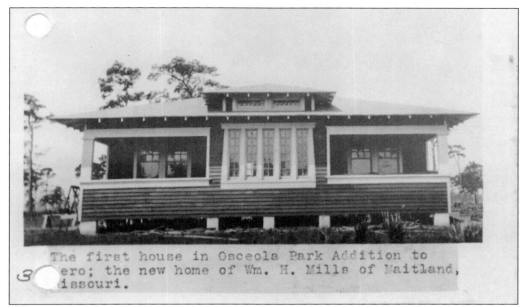

The first house in Osceola Park Addition to
ero; the new home of Wm. H. Mills of Maitland,
issouri.

INDIAN RIVER FARMS COMPANY, OSCEOLA PARK HOME SITES. An advertisement for Osceola Park Home Sites appeared in the Indian River Farms Company plat book. "Vigorous Vero" had good water, schools, churches, neighbors, roads, boating, bathing, fishing, hunting, and motoring in that advertisement from 1917. This postcard is of the first home in Osceola Park Addition, the home of William H. Mills. (Published by Commercial Photographic Company; courtesy HS.)

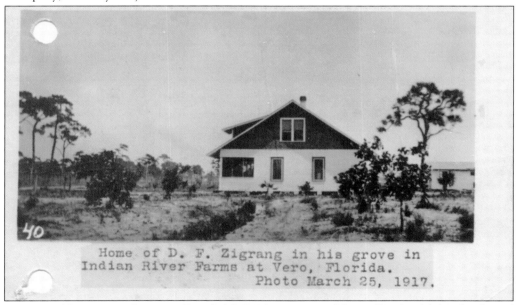

Home of D. F. Zigrang in his grove in
Indian River Farms at Vero, Florida.
Photo March 25, 1917.

ZIGRANG HOME AND GROVES. Dominick F. Zigrang moved from Illinois with his family and settled west of Vero in 1914 at Thirty-seventh Avenue and Highway 60. He built a home and planted citrus groves, seen in this postcard dated March 25, 1917. (Published by Commercial Photographic Company; courtesy HS.)

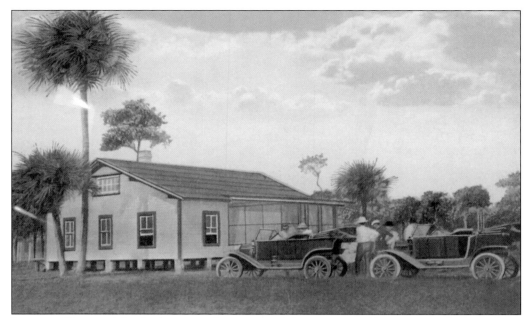

BARBER HOME. Helen Barber arrived in Vero with her son, Merrill, in 1913, to the home built by her husband, who had preceded them. Dr. Merrill Barber was president of the Indian River Planters Association (renamed Indian River Growers Association) formed in 1914. Organized to share growers' concerns, the association decided from the onset to market a quality product packed in the best possible way. (Published by L. B. Kopp; courtesy SMI.)

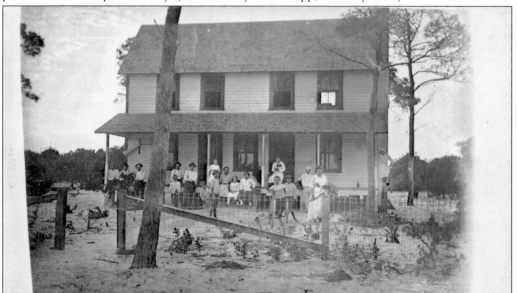

HARRIS HOME. Roy Waker, an early photographer in Vero, provided the picture for this postcard of the Harris home on Old Dixie Highway and Twelfth Street. Shown are the Harris, Leffler, and Waker families, all close friends. Louis Harris, president of Farmer's Bank and chairman of the Board of Public Instruction of St. Lucie County, arrived in Vero in 1890. (Courtesy HS.)

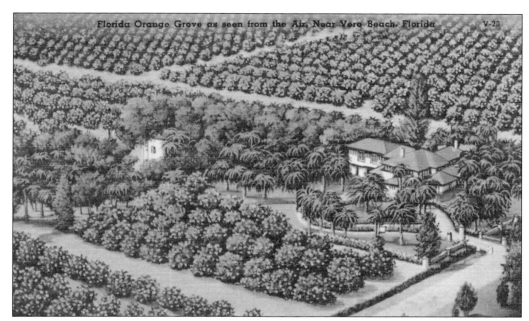

ANDREWS HOME, AERIAL VIEW. Judge James E. Andrews's residence was constructed around April 1915 on Osceola Boulevard and Fifty-eighth Avenue (formerly Oak Terrace Rest), two miles west of Vero, nestled in a grove of palm trees. He had an artesian well, citrus groves, and vegetable fields. (Published by Eli Witt Tobacco; courtesy SMI.)

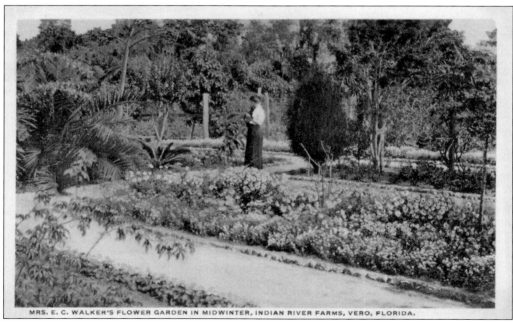

WALKER HOME. In 1915, Eli Walker built a magnificent new residence at Osceola Boulevard and Kings Highway. Featured is Mrs. Delgracio Walker in her flower gardens in midwinter. She was famous for her roses. (Published by C. T. American Art; courtesy SMI.)

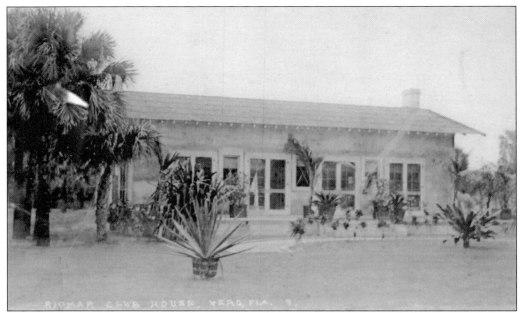

RIOMAR CLUB HOUSE. The 160 acres of land comprising the original Riomar Development were purchased in 1919 for a few thousand dollars in gold coin. The development of this small community on the barrier island, which included a golf course, was entrusted to Alex MacWilliam. Pictured is the original Riomar Clubhouse. The name Riomar was selected because in Spanish it is a combination of "river" and "sea." (Published by Eastern Illustrating Company; courtesy SMI.)

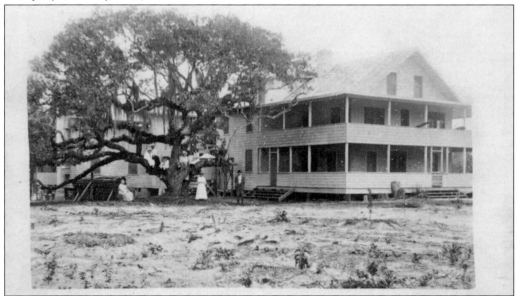

LIVE OAK HOTEL. The reverse states that this is a hotel on the island across from Vero, May 13, 1917. J. C. McCann's road connecting the new bridge to the beach ran past this hotel. Prior to the building of the Vero Bridge in 1920, guests were ferried to the island by boat. (Courtesy HS.)

Four

WATCH US ROAR (1920S)

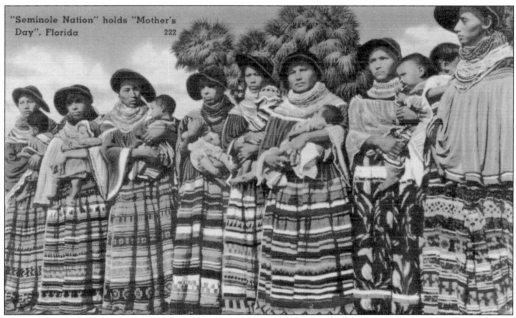

SEMINOLE INDIANS. The 1920s were a time when the business areas grew rapidly; plans were made for skyscrapers. Participation in civic activities was strong. New businesses were started everywhere. This continued until 1927, when many businesses and banks failed. According to Dorothy Fitch Peniston in her memoir *An Island in Time*, in the early 1920s, Seminole Indians dressed in traditional garb were regularly seen on the unpaved streets of Vero on Saturdays shopping for necessities. Peniston remembered that downtown streets were often either very dusty or muddy and that the sidewalks were raised board planks. (Published by Tichnor Quality Views; courtesy AC.)

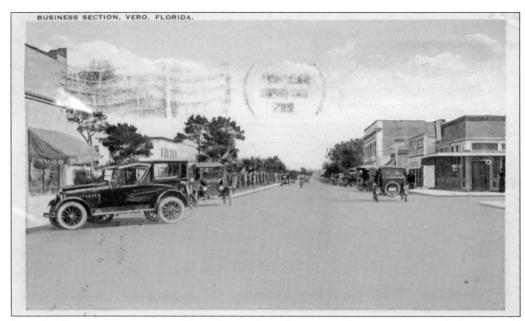

VERO'S BUSINESS SECTION. Osceola Boulevard (Twentieth Street), part of the original platting of downtown Vero, is the only street to retain its Native American name. The first agricultural fair in April 1915 was held at the east end of Osceola Boulevard, sponsored by the Woman's Club, the board of trade, and the Indian River Growers Association. (Published by Tichnor Quality Views; courtesy SMI.)

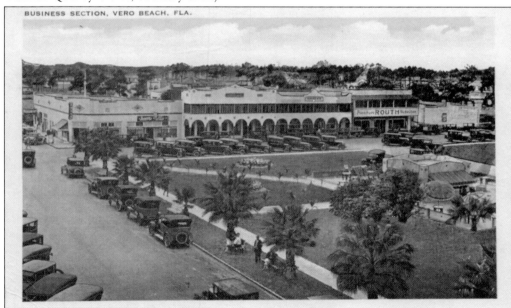

VERO'S BUSINESS SECTION. In 1914, P. T. Burrows, an architect from Davenport, Iowa, created plans for Charles Grilk of Davenport, head of Indian River Development Company, for a business block in Vero. It was unique in that it was planned for both beauty and comfort, with a roofline extending out over the sidewalk. (Published by Tichnor Quality Views; courtesy SMI.)

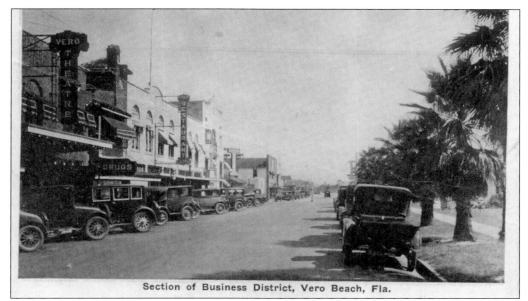

Section of Business District, Vero Beach, Fla.

A SECTION OF VERO'S BUSINESS DISTRICT. Portrayed is Seminole (Fourteenth) Avenue, Vero Beach, looking south. The theater and Vero Restaurant are on the left. The theater was built by William Atkin and was designed in the Mediterranean Revival style. It opened in October 1924. The first feature film shown there was the *Hunchback of Notre Dame*. It is currently the Theatre Plaza, restored by Robert L. Brackett. (Published by Auburn Post Card Manufacturing; courtesy SMI.)

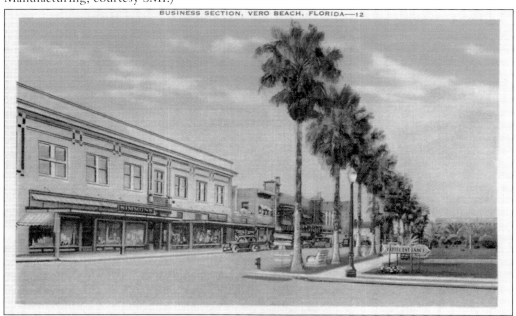

BUSINESS SECTION, VERO BEACH, FLORIDA—12

STREET VIEW, DOWNTOWN VERO: SIMMONS AND THE SEMINOLE BUILDING. Vero's streets were planned for beauty as well as commerce. Seminole Grocery, owned first by W. Riggs and then by Roy Waker, was in the Seminole Building, as was Simmons' Dry Goods Store. (Published by E. C. Kropp Company; courtesy SMI.)

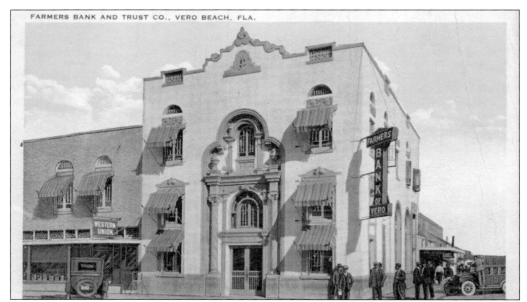

FARMER'S BANK, VERO. Farmer's Bank, the first bank in the county, was completed by F. H. Trimble in November 1914 at the corner of Osceola Boulevard and Seminole Avenue. It ceased operations in the early 1930s. Later the Citrus Bank was chartered and opened in this building. At one time, a tunnel under Twentieth Street connected to drive-in and walk-up windows. The building is currently occupied by Vero Furniture. (Published by Tichnor Quality Views; courtesy SMI.)

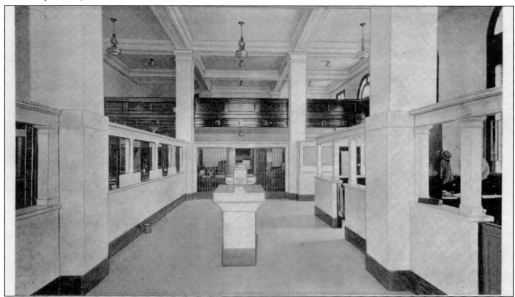

FARMER'S BANK INTERIOR. Judge J. E. Andrews was the first president of Farmer's Bank. All stock was held by local residents. The bank's interior featured mahogany and brass counters and a marble interior finish. The building housed the Vero Grocery Company, a drugstore, and the List and Gifford Construction Company, as well as the bank. (Published by Tichnor Quality Views; courtesy SMI.)

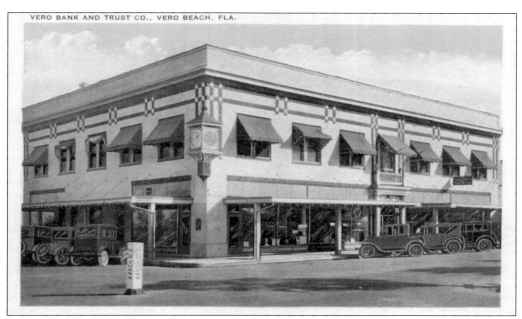

VERO BANK AND TRUST COMPANY. In 1923, Vero Bank and Trust Company joined with the other bank in Vero, Farmer's Bank, to buy the city's $217,000 bond issue. The bonds would pay for seven miles of street paving and two miles of storm sewers. The bank went into receivership, and in 1930, some moneys (four percent of claims) were paid to the depositors by T. A. Stewart. (Published by Tichnor Quality Views; courtesy AC.)

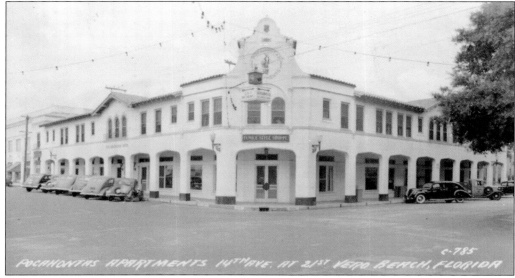

POCAHONTAS BUILDING, VERO. The Indian River Farms Company had a local office in the Pocahontas Building, a single-story building on the corner of Fourteenth Avenue and Twenty-first Street built by Dr. J. L. Hutchison. A second story was completed in 1926. Shops and offices were on the first floor, and the Pocahontas Apartments, some of which overlooked the interior courtyard, were on the second floor. (Published by the L. L. Cook Company; courtesy HS.)

49

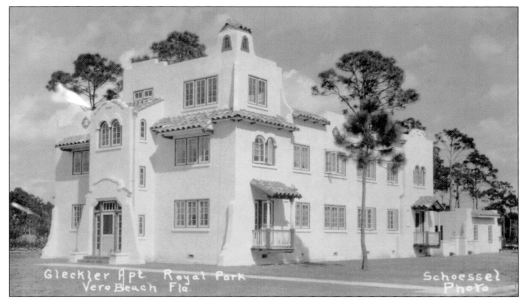

Gleckler Apt Royal Park
Vero Beach Fla.

Schoessel Photo

GLECKLER APARTMENTS, VERO BEACH. As part of the "Post Card Week" advertising campaign, 1,800 copies of this postcard of the newly built Gleckler Apartments were mailed out in March 1927. Clayton Gleckler built the Gleckler Apartments in 1926 in the fashionable Mediterranean Revival style on Royal Palm Boulevard. Over the years, it became the Royal Park Apartments, Ray Mar Towers, and finally the Royal Viking Apartments. (Published by Noko; courtesy SMI.)

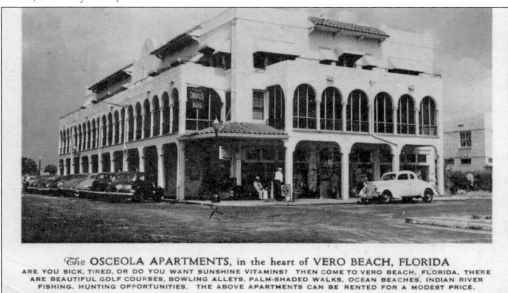

The OSCEOLA APARTMENTS, in the heart of VERO BEACH, FLORIDA
ARE YOU SICK, TIRED, OR DO YOU WANT SUNSHINE VITAMINS? THEN COME TO VERO BEACH, FLORIDA, THERE ARE BEAUTIFUL GOLF COURSES, BOWLING ALLEYS, PALM-SHADED WALKS, OCEAN BEACHES, INDIAN RIVER FISHING, HUNTING OPPORTUNITIES. THE ABOVE APARTMENTS CAN BE RENTED FOR A MODEST PRICE.

OSCEOLA APARTMENTS, VERO BEACH. In 1926, extensive renovations to the Osceola Apartments were made by the new manger, Mrs. J. W. Bowman. A lobby and reception area with a fireplace was converted from an apartment. Four apartments were converted into two larger ones for family accommodations. Linens, silverware, china, and culinary equipment were provided to guests for the first time. The building has been torn down. (Courtesy SMI.)

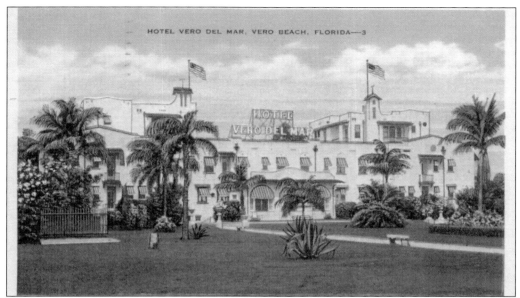

HOTEL VERO DEL MAR. The Hotel Vero Del Mar was built in 1926 adjacent to the Sleepy Eye Lodge. The 55-room hotel was a very popular year-round facility. It had landscaped grounds and an excellent dining room. A large alligator, King Bulger, occupied a cage on the lawn for three years in the early 1930s. In 1962, the hotel was demolished to make room for a parking lot. (Published by E. C. Kropp Company; courtesy SMI.)

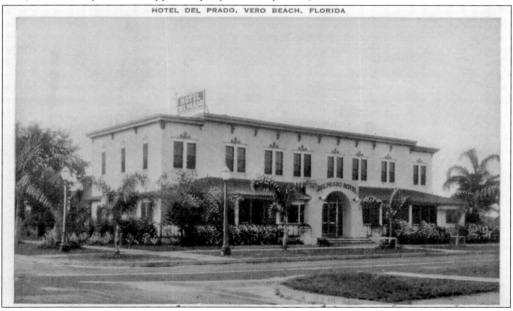

HOTEL DEL PRADO, VERO BEACH. In order to allow the Del Mar Hotel to expand, the Sleepy Eye Lodge was moved to Nineteenth Avenue and Twenty-second Street. In 1920, C. E. Cobb leased the Sleepy Eye Lodge and attempted to expand with tents in the back and beds on the porch, but this was not popular with guests. It was renamed the Del Prado in 1927. Most of it was torn down in 1960. (Published by E. C. Kropp Company; courtesy SMI.)

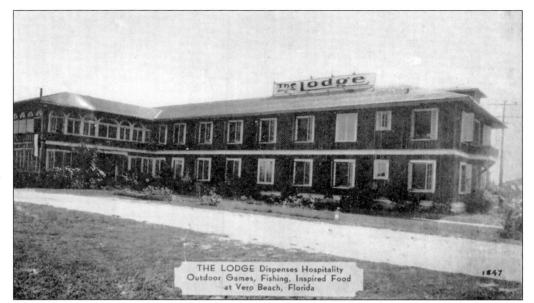

THE LODGE Dispenses Hospitality
Outdoor Games, Fishing, Inspired Food
at Vero Beach, Florida

THE VERO BEACH LODGE. The Vero Beach Lodge opened in February 1926 on Dixie Highway, two blocks from the post office. It was constructed for T. A. Ryburn, a builder of homes in Royal Park. The 50-room hotel was advertised as "moderately priced." A. W. Ryburn, the son of the owners, managed the hotel. It is now a vacant lot. (Published by Dexter Press; courtesy SMI.)

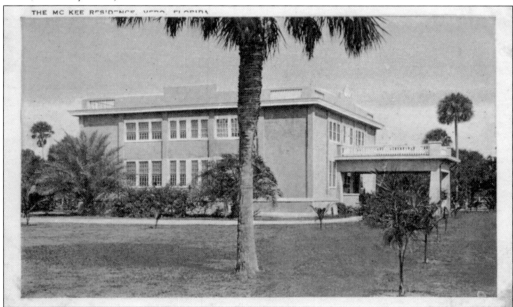

McKEE RESIDENCE, RIOMAR. Arthur G. McKee was born in Pennsylvania and later moved to Cleveland, where he founded a company that designed and built industrial plants. After wintering in Indian River County for many years, he built a residence in Riomar in 1922 in the Mediterranean Revival style with an exterior finish of stucco and oyster shell. He was the creator of McKee Jungle Gardens. (Published by Tichnor Quality Views; courtesy SMI.)

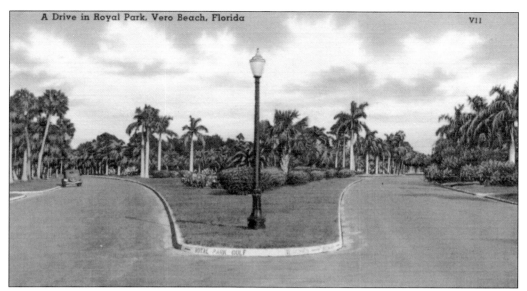

ROYAL PARK SUBDIVISION. The beautiful, avant-garde Royal Park subdivision was professionally planned and laid out with homes backing on a golf course. Blueprints were drawn by Waldo Sexton. Lots were accessed by curving graded streets lined with royal palm trees. Drainage ditches were dug. Prior to the commencement of lot sales in 1924, $200,000 was invested in the creation of the subdivision. (Published by Tichnor Brothers, Tichnor Quality Views; courtesy SMI.)

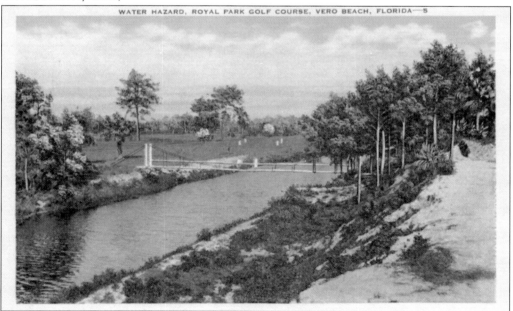

ROYAL PARK GOLF COURSE. From 1924 to 1927, sales in Royal Park were brisk, but the Depression halted land sales and purchasers defaulted on payments. The company went bankrupt in 1932 and announced the closure of the golf course. A golfers association was formed to take over the operation of the golf course. The property is now the Vero Beach Country Club. (Published by E. C. Kropp; courtesy SMI.)

SEBASTIAN INLET. Early in the area's history, it was decided that an inlet from the Indian River to the Atlantic Ocean at the Sebastian River was an economic necessity for fishing. All early attempts at digging the cut failed, commencing with New's Cut, Gibson's Cut, and others in the 1880s. Not until 1923 was a successful inlet opened at the Gibson's Cut site. (Published by Florida Card and Novelty; courtesy SMI.)

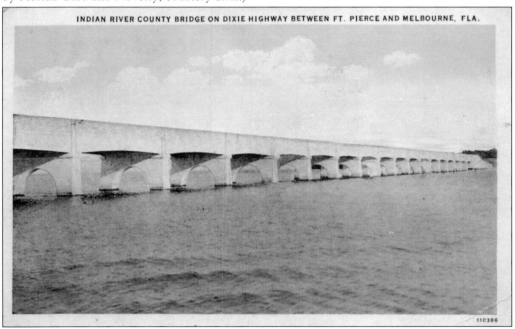

INDIAN RIVER COUNTY BRIDGE ON DIXIE HIGHWAY BETWEEN FT. PIERCE AND MELBOURNE, FLA.

110386

SEBASTIAN RIVER BRIDGE. The bridge across the Sebastian River is famous as the site where the Ashley Gang was cornered and killed at the south end of the bridge the night of Saturday, November 1, 1924, by Sheriff J. R. Merritt of St. Lucie County and a group of local and Palm Beach deputies. (Published by Asheville Post Card Company; courtesy SMI.)

VERO BRIDGE. Vero Bridge was the first bridge in this area. Constructed of wood and cabbage palms with a steel swing span, it was slated to open Labor Day, September 6, 1920, and local citizens helped finish it. Around 150 cars passed over the bridge and onto the dirt road that day, making it muddy and deeply rutted. Many returning cars became stuck and had to be pushed out by volunteers or pulled out by tractor. (Published by Noko; courtesy HS.)

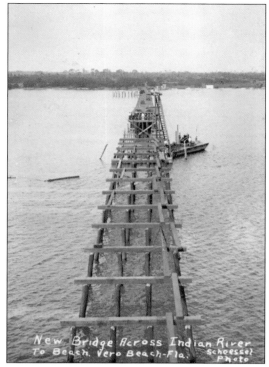

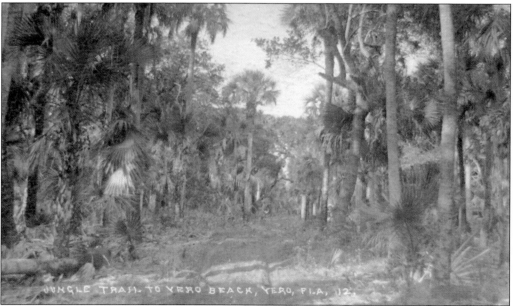

THE JUNGLE TRAIL, ORCHID ISLAND. In the 1920s, the county created the 14-mile-long Jungle Trail to facilitate travel on Orchid Island. It later became State Road 252, and part of it is now Highway A1A. Seven and a half miles of it remain as a public road retaining the Jungle Trail name. It is listed in the National Register of Historic Places. (Published by Eastern Illustrating; courtesy SMI.)

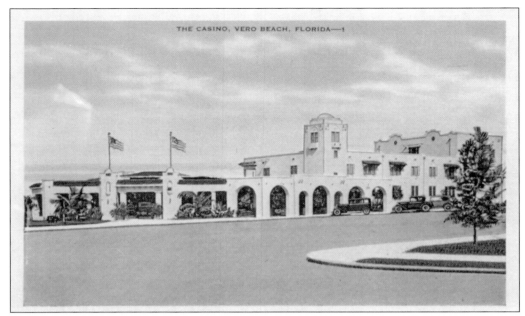

BEACHLAND CASINO. Beachland Casino, in the Sexton Plaza on the ocean, was dedicated with dancing and sporting events during Vero's afternoon Armistice Day celebrations November 11, 1921. Trucks provided transportation for participants. Two hundred and six motor vehicles and 1,050 people crossed the bridge and paid toll for the afternoon's events. By 1923, a hotel and cottages were added. It was demolished in the 1960s, replaced by a Holiday Inn. (Published by E. C. Kropp; courtesy SMI.)

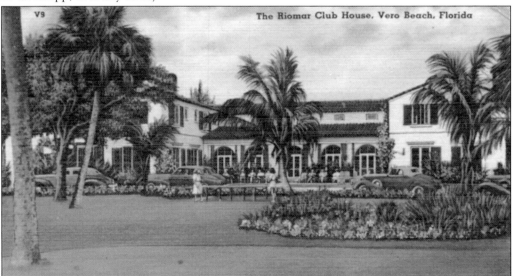

RIOMAR CLUB HOUSE. From 1919, as the development prospered, Riomar grew as a spot where friends could build homes, golf, and fish. By 1920, the golf course was completed. A clubhouse, guesthouse, and tennis courts were added. In the following six years, around 12 houses were built. In the 1920s, electricity was added. Pres. Warren G. Harding was a guest at Riomar. (Published by Eli Witt Tobacco; courtesy SMI.)

Five

BUSINESS GROWTH (1930s)

HERMAN AND ADELAIDE ZEUCH, ? SMITH, AND ROBBIE ? IN HAVANA (FROM LEFT TO RIGHT). The Depression in the 1930s had a dramatic impact on the area. Several banks and building projects failed, but Federal Emergency Relief Administration (FERA) projects resulted in the building of the courthouse, the community center, and others. McKee Jungle Gardens opened, and the Driftwood Inn was built. The airport opened, and Eastern Airlines arrived. Herman Zeuch was involved in banking and in developing communities in Davenport, Iowa, and elsewhere before coming to Vero. He became the first major developer in the area as head of the Indian River Farms Company. Its main office remained in Davenport, however, with a branch office in Vero. As a result of the Depression, by 1935, Zeuch sold out his Davenport holdings and moved to Vero. He is on the Great Floridians list. (Published by Tropical Garden; courtesy HS.)

COMMUNITY CENTER, VERO BEACH. The community center was built during the New Deal era, a FERA project that was popular with residents and visitors alike as the center of social and entertainment activities and as headquarters of the Tourist Club. A small zoo contained a bear named Alice, an alligator, monkeys, and other animals. Now named the Heritage Center, it is listed in the National Register of Historic Places. (Published by E. C. Kropp; courtesy SMI.)

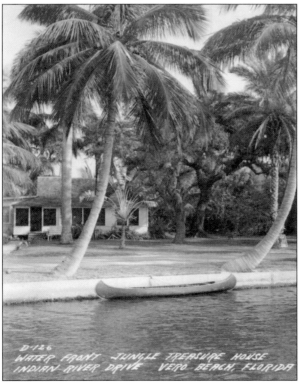

JUNGLE TREASURE HOUSE. The Jungle Treasure House was owned by George S. Dales, a photographer and merchant of antique jewelry. He and his family lived in Akron, Ohio, and after 1900 made numerous trips to North Florida. The Treasure House was opened about 1939, after the Dales retired and moved to Indian River County. (Published by the L. L. Cook Company; courtesy SMI.)

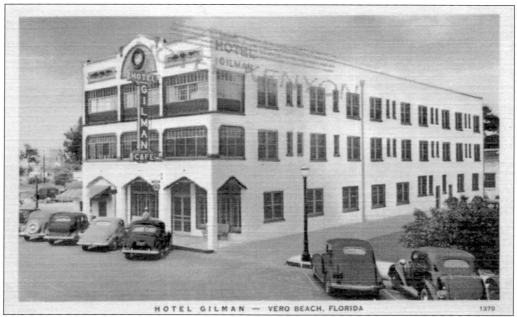

HOTEL GILMAN, VERO BEACH. Pictured is the Hotel Gilman, and on the extreme left is the Western Meat Market, on Fourteenth Avenue between Twentieth Street and Nineteenth Place in Vero Beach. It was purchased in May 1943 by Paul Luther and renamed the Kenyan, which is stamped across the card. It was also named the Luther Hotel. It later became a vacant, landscaped lot. (Published by L. L. Cook Company; courtesy SMI.)

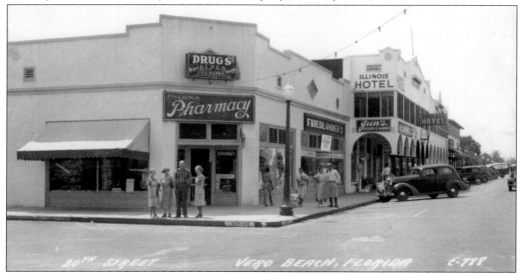

FOURTEENTH AVENUE AND TWENTIETH STREET, VERO BEACH. At Vero Beach's center were Osceola Pharmacy, Friedlander's, Jun's Grocery, Illinois Hotel, and Skiscim Studio. Jun's Grocery, constructed in 1919, was transformed by Thomas E. Jun into a model grocery in 1930 based on a modern merchandising plan approved by the U.S. Department of Agriculture. Over it was the Illinois Hotel with Elsie Toole as proprietor. The building was demolished in 1967. (Published by L. L. Cook Company; courtesy SMI.)

MRS. CHESSER, 1933. Meta M. Chesser was a schoolteacher. The Chesser families were pioneers in the Indian River area; Lemuel Chesser was a retired grower who came from Virginia and settled in Sebastian around 1919, and other Chessers settled in Wabasso around 1921. They are related to the Ayers and Kennedy families, known for their groves; Frank Ayers is also known for his fossil discoveries. (Published by Noko; courtesy HS.)

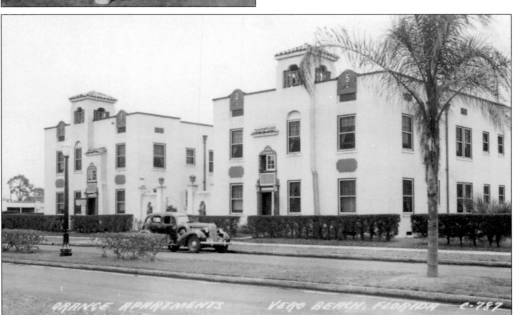

ORANGE APARTMENTS, VERO BEACH. The Orange Apartments were built by noted architect F. H. Trimble in the mid-1920s on Nineteenth Place, Edgewood Addition, Vero Beach. This U-shaped building faces north. Apartments are still at this location. (Published by L. L. Cook Company; courtesy HS.)

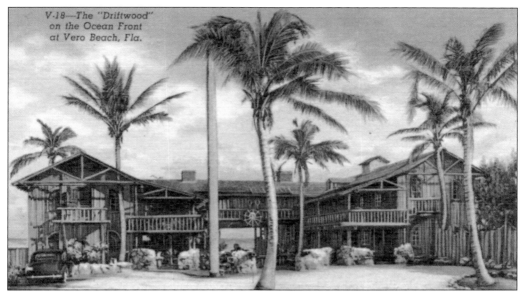

THE DRIFTWOOD INN. The Driftwood Inn was originally built in 1935 by Waldo Sexton. Waldo used his extraordinary entrepreneurial talents in 1913 to sell plows in Vero but quickly became a spokesman for the Indian River Farms Company. As well as the Driftwood, his many enterprises included real estate, fruits and vegetables, a dairy, Oslo Hammock Corporation, Oslo Packing, Waldo's Mountain, and several restaurants and clubs. He is on the Great Floridians list. (Published by F.E.C. News; courtesy HS.)

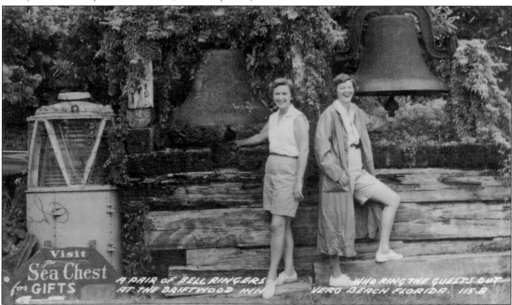

A PAIR OF BELL RINGERS, DRIFTWOOD INN. The Driftwood expanded during 1936–1939 using an eclectic mix of items salvaged by Sexton. It is famous for its collection of old empty liquor bottles, bells (as many as 250), wrought-iron grille-work, a casket, portholes, mastodon bones, gambling-house tables, whalebones, old tiles, and antique cannons, among its artifacts. (Published by L. L. Cook Company; courtesy SMI.)

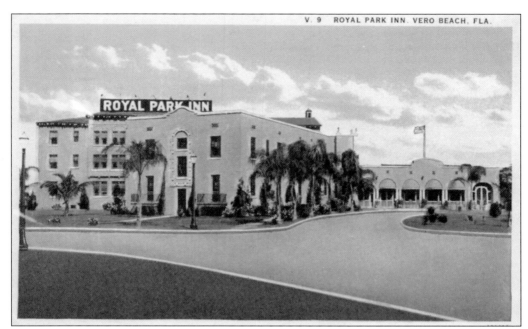

ROYAL PARK HOTEL. The Royal Park Hotel, designed by F. H. Trimble, was built by Fred Doeschner in 1924 on lots in the Royal Park subdivision. It went bankrupt at the end of the boom. The property was purchased in 1937 by L. C. Treadway, who refurbished it and added it to the successful line of Treadway Inns. Condominiums now occupy the site. (Published by Asheville Post Card Company; courtesy SMI.)

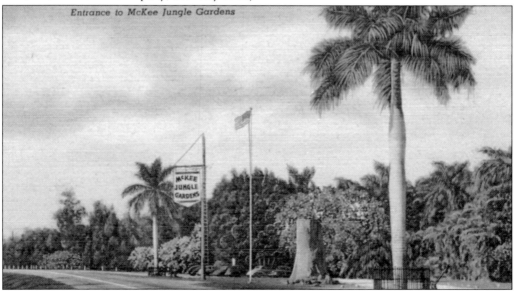

Entrance to McKee Jungle Gardens

MCKEE JUNGLE GARDENS. In 1925, McKee Jungle Gardens began as Royal Park Exotic Nurseries. In 1932, it was opened to the public as a tourist attraction for families, featuring more than 2,000 tropical plants from around the world and 300 animals. Except for the World War II years, when it was closed to the public, it remained open until 1976. McKee Botanical Garden opened in 2001 on part of the original acreage. (Published by Curteich; courtesy SMI.)

Six

THE COMMUNITY GOES TO WAR (1940S)

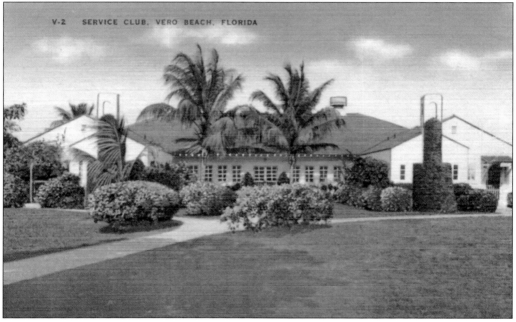

COMMUNITY CENTER, VERO BEACH. World War II brought many changes. In 1942, the Vero airport was taken over by the federal government, and it became a U.S. naval air training station. With the large influx of military personnel, local establishments were appropriated to house, feed, and entertain them. In 1943, the community center was enlarged—adding the north wing with a lounge, restrooms, and showers—to become a servicemen's club organized by director Dale Wimbrow. This wing has become the Indian River Citrus Museum. (Published by Hartman Litho Sales; courtesy SMI.)

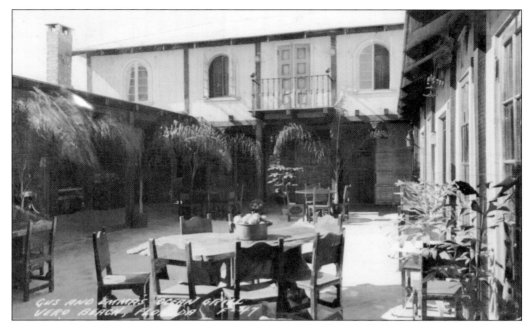

GUS AND EMMA'S OCEAN GRILL RESTAURANT. The Ocean Grill Restaurant was known for its excellent food and entertainment. During World War II, the Ocean Grill Restaurant became the "Club Mac," a very popular spot for the officers of the U.S. Naval Air Station. This was particularly true as nearly 100 WAVES were housed at the Windswept Hotel across the street. (Published by L. L. Cook Company; courtesy SMI.)

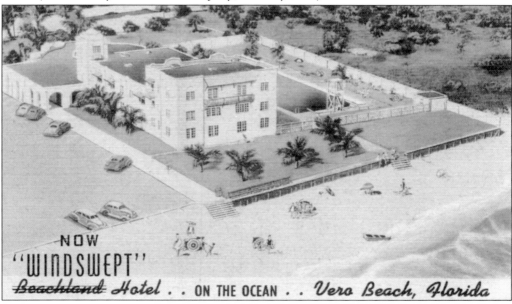

THE WINDSWEPT. The Windswept was formerly the Beachland Casino Hotel, as indicated on this card. This luxurious and popular hotel on the ocean quartered WAVES from the U.S. Naval Air Station in Vero Beach for the duration of World War II. (Published by Colorpicture; courtesy SMI.)

McKee Parrots. McKee Jungle Gardens had its part to play during World War II. Its parrots were loaned out to entertain service personnel at the service club. One of them sang "Frere Jacques" in French to the troops. (Published by W. M. Cline Company; courtesy SMI.)

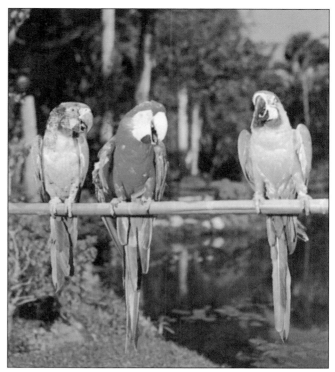

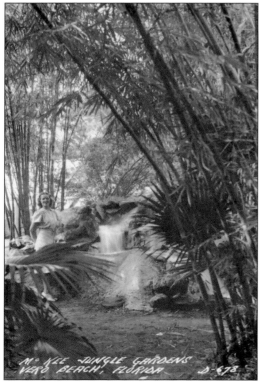

McKee Jungle Gardens. McKee Jungle Gardens proved to have a more important mission than mere entertainment during the war years. In preparation for war in the Pacific theater, thousands of navy men and marines trained in jungle warfare in the gardens, learning how to fight in jungle conditions and how to live off the land in a jungle without regular rations. (Published by L. L. Cook Company; courtesy SMI.)

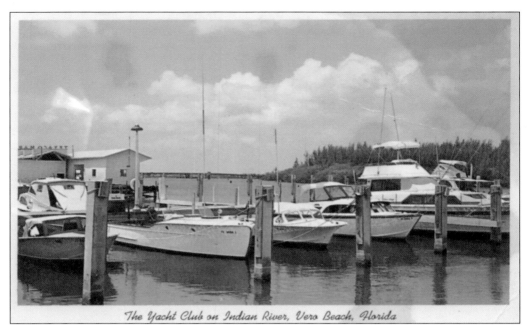

The Yacht Club on Indian River, Vero Beach, Florida

VERO BEACH YACHT CLUB. The Vero Beach Yacht Club played an important role during the war years, serving as a meeting place for the Motor Corps, created by the Red Cross as one of their Volunteer Special Services. The Motor Corps provided training in motor mechanics. Its first class met January 18, 1943. Boys trained as Sea Scouts. (Published by D&M Post Cards and Records Company; courtesy SMI.)

GONE FISHING. Another service provided by the yacht club was selling bait. More and more people became sport fishermen to augment their diet as meat rations ran out. Availability of bait and the arrival of bait shipments were constant concerns during this time. (Courtesy HS.)

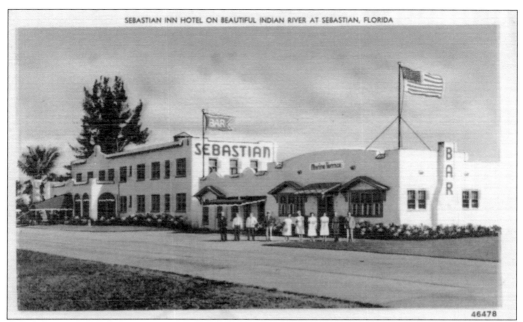

46478

SEBASTIAN INN. The Sebastian Inn, built in 1925 on the shore of the Indian River in Sebastian, was a popular local gathering spot. The inn's two boats, the *Jungle Bell* and *Leading Lady*, offered scenic cruises. During World War II, U.S. Marines who operated a so-called secret radar station at U.S. 1 and Main Street were quartered there. The building was demolished in 1968. (Published by L. L. Cook Company; courtesy AC.)

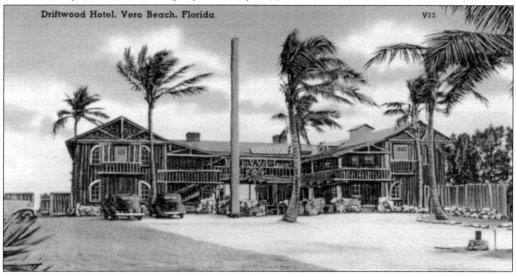

Driftwood Hotel, Vero Beach, Florida V13

DRIFTWOOD INN. During World War II, the inn was rented out. In the tourism boom following the war, the Driftwood expanded, adding war-surplus cottages and a concrete dynamite storage building that was renovated into a walk-in refrigerator. The expansion and renovations to the Driftwood continued until 1979, when the Sextons sold the complex to Driftwood Resorts, which converted it to time-share condominiums. (Published by Eli Witt Company; courtesy SMI.)

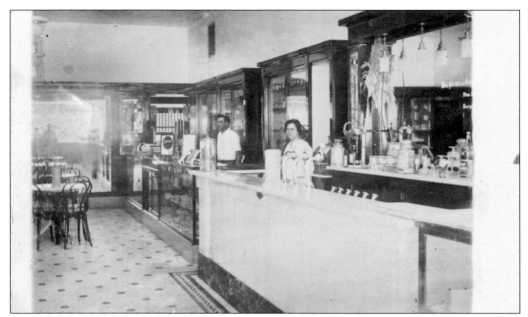

THE VERO DRUG COMPANY. Owner Thomas William Radinsky and clerk Maude Waker are featured in this interior shot of Radinsky's drugstore in the Seminole Building. Drugstores, with their soda fountains and tables, provided a popular downtown gathering spot for shoppers. (Courtesy HS.)

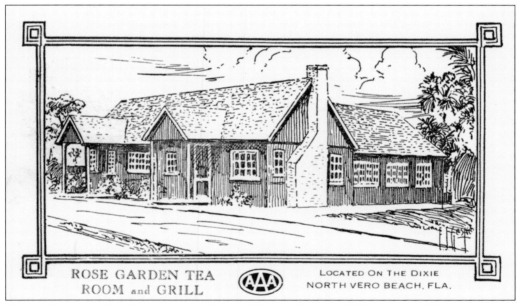

ROSE GARDEN TEA
ROOM and GRILL

AAA

LOCATED ON THE DIXIE
NORTH VERO BEACH, FLA.

ROSE GARDEN TEA ROOM AND GRILL, VERO BEACH. With elegant table settings and memorable food, this was Vero Beach's swankiest spot during the 1930s and 1940s. In addition to a rose garden, it had a strawberry patch. One feature of the menu was that it cooked a fisherman's own catch for him. It later became Marvin Gardens and was torn down and moved at the beginning of the 21st century. (Courtesy SMI.)

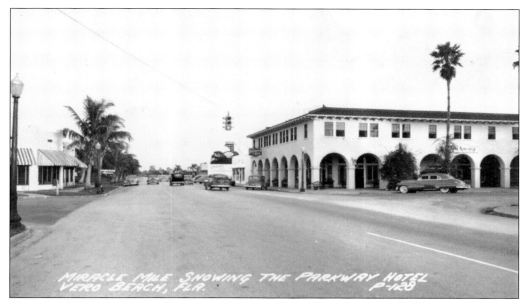

MIRACLE MILE SHOWING PARKWAY HOTEL, VERO BEACH. By 1947, Twenty-first Street in Vero Beach had been renamed "Miracle Mile" and was ready for paving. Miracle Mile is an east-west road running from U.S. 1 to Indian River Boulevard. In addition to individual stores, developers planned to include Vero's first shopping plaza. Downtown merchants worried that the plaza's popularity would adversely affect their businesses. (Published by L. L. Cook Company; courtesy HS.)

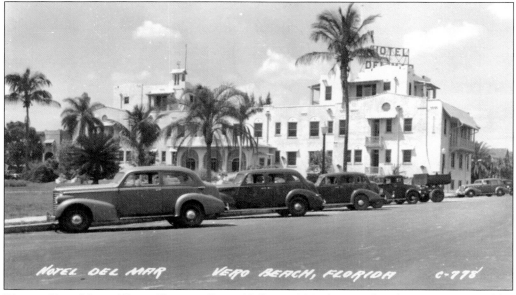

HOTEL DEL MAR, VERO BEACH. From 1943 to 1946, the Hotel Del Mar was owned by Tony Young, a politician and public-relations man in Vero Beach known as "Uncle Tony" by everyone. In 1919, the village of Vero incorporated, and he was the first mayor. He later became the St. Lucie County representative and a state senator, and he was instrumental in the formation of Indian River County. (Published by L. L. Cook Company; courtesy SMI.)

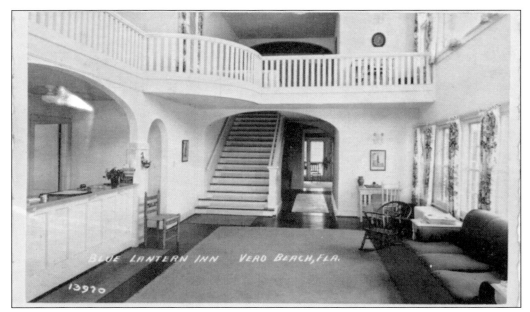

BLUE LANTERN INN (VERO BEACH HOTEL/FRANTZ MOTOR LODGE), VERO BEACH. The Blue Lantern Inn was built by the Indian River Farms Company. From 1944 to 1962, it changed hands several times. Due to its location near the railroad tracks, some visitors complained that the trains "came in one window and went out another." In 1962, it was torn down. Fairlane Sporting Goods was built there. (Published by L. L. Cook Company; courtesy SMI.)

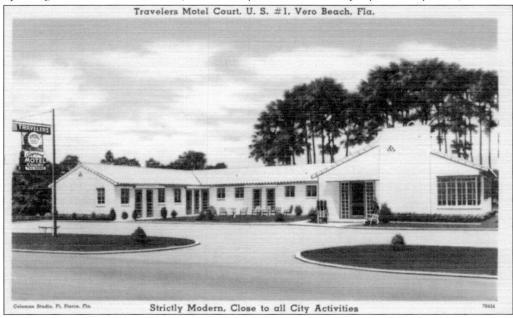

TRAVELERS MOTEL COURT, VERO BEACH. The Travelers Motel opened in 1947. It was located on U.S. 1 in the 1800 block. There were 10 units, and the owners/operators, Mr. and Mrs. Orla Shelton, occupied the right wing. An International House of Pancakes occupies that space now. (Published by Tichnor Quality Views; courtesy SMI.)

70

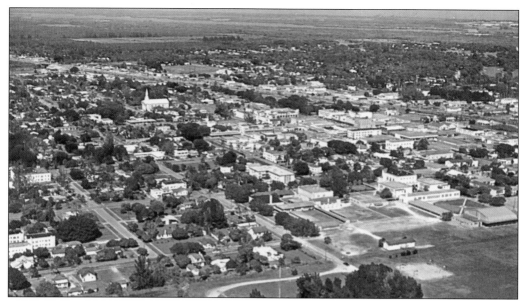

AERIAL VIEW, VERO BEACH. Aerial views such as this were made possible by the Vero Beach Airport, dedicated in 1930. Eastern Air Transport (Eastern Air Lines) used the airport for refueling. Major expansion and improvements occurred during World War II, when it served as a U.S. Naval Air Station. After the war, the Brooklyn Dodgers baseball team purchased several of the buildings and adjacent land. (Published by D&M Post Cards and Records; courtesy SMI.)

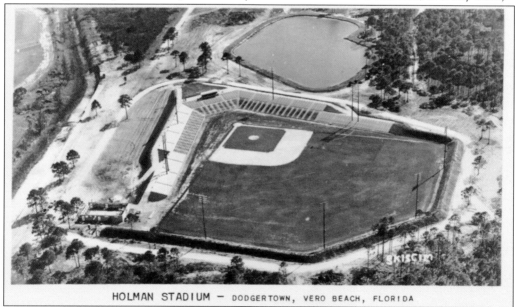

HOLMAN STADIUM — DODGERTOWN, VERO BEACH, FLORIDA

HOLMAN STADIUM, VERO BEACH. In 1948, the Brooklyn Dodgers moved their training site from Havana, Cuba, to Vero Beach. Holman Stadium and Dodgertown were built on 109 acres of former airport/naval air station land. The stadium was named for Bud Holman, airport manager and director of Dodgertown. Street signs in Dodgertown bear the names of Jackie Robinson, Roy Campanella, Pee Wee Reese, and other Dodgers in the hall of fame. (Courtesy HS.)

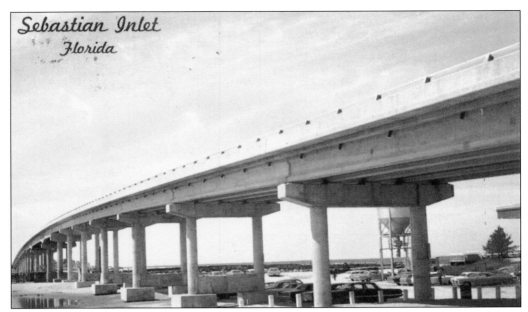

SEBASTIAN INLET. From the 1920s until 1941, the inlet remained open sporadically. Due to lack of maintenance, it was closed during World War II. In 1948, the Sebastian Inlet Tax District reopened it and continues to maintain it. Sebastian Inlet State Park is located on both sides of the channel. (Published by H. S. Crocker; courtesy SMI.)

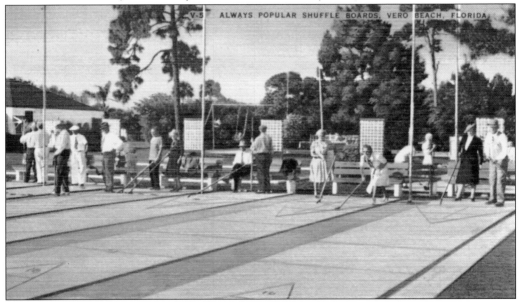

COMMUNITY CENTER SHUFFLEBOARD COURTS, VERO BEACH. Following the widespread growth in popularity of shuffleboard, the county boasted of several courts. As well, World War II soldiers routed through the eastern United States acquired a love for the game and thus spread the game nationwide. Military bases, fraternal clubs, rehabilitation hospitals, and community centers of all sorts had shuffleboard courts, including the Servicemen's Club (community center) in Vero Beach. (Published by Hartman Litho Sales; courtesy SMI.)

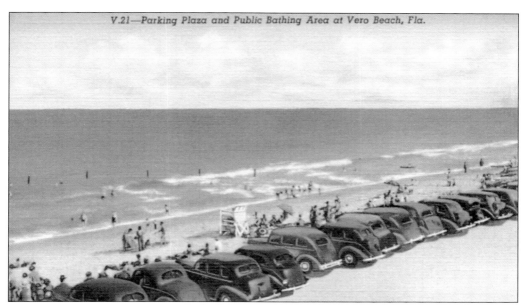

OCEAN PARKING PLAZA AND PUBLIC PARKING AREA. In June 1949, Vero Beach summer visitors were setting new records. Beach resorts and Route 1 motels were at capacity. McKee Jungle Gardens had already had as many visitors as in the entire year of 1948. Real estate companies had many inquiries about buying property. A Cincinnati newspaper had an advertisement for Vero Beach in the resort section. (Published by Florida Post Card Company; courtesy SMI.)

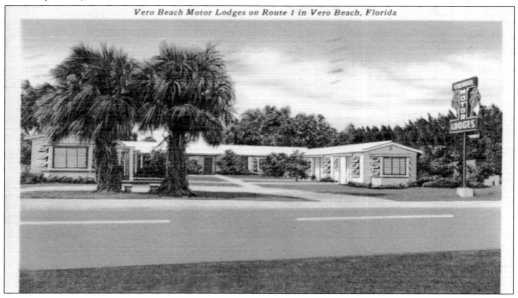

Vero Beach Motor Lodges on Route 1 in Vero Beach, Florida

VERO BEACH MOTOR LODGES. Vero Beach Motor Lodges was located on Miracle Mile, "with all refinements." The prosperity at the end of World War II and the popularity of the automobile as a growing means of transportation saw the rise of many small motels catering to families on vacation. Most of these are gone now, including this one. A thrift shop is there now. (Published by Tichnor Brothers; courtesy SMI.)

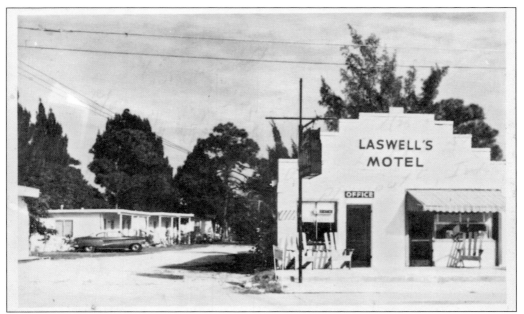

LASWELL'S MOTEL, VERO BEACH. Laswell's Motel was owned and operated by Russell W. Laswell, who moved with his family to Vero Beach in 1947 from Indiana. The eight-unit motel was originally named Fika Cottage Court and was purchased from John Fika in 1947. Laswell and his wife, Emma, also owned and operated Laswell's Barber Shop and Laswell's Beauty Shop, all located on Commerce Avenue in Vero Beach. (Published by Postcards by Maher; courtesy SMI.)

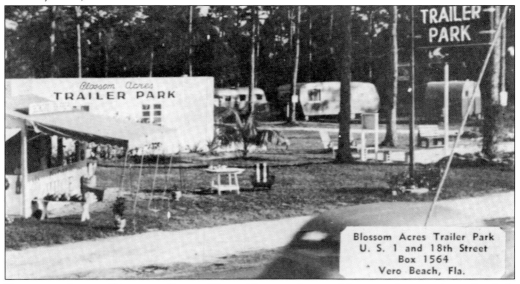

BLOSSOM ACRES TRAILER PARK, VERO BEACH. Some visitors to the area brought their temporary lodging with them. Blossom Acres on U.S. 1 and Eighteenth Street advertised that it was for "discriminating trailer travelers" and was near shopping, fishing, boat docks, shuffleboards, and beaches. This was later operated by the Laswells. (Published by Dexter Press; courtesy SMI.)

Seven

INDIAN RIVER
ON THE MAP (1950S)

QUEENIE AND WALDO SEXTON AT THE DRIFTWOOD. Waldo Sexton's flair for the dramatic was never more evident than the day he brought Queenie the elephant into the Driftwood Inn to greet dinner guests. She stood in the doorway and rang a bell, as shown here, posed with Sexton, in December 1959. According to the *Press Journal*, when queried, he said, "You mean all Florida hotels don't have elephants greeting their guests?" Queenie is not to be confused with "Denice the Menace," the elephant that escaped from McKee Jungle Gardens in 1954 and went for a swim in the Indian River. She was rounded up by airplanes, boats, fire and police departments, high school boys, and the U.S. Coast Guard. (Courtesy DAN.)

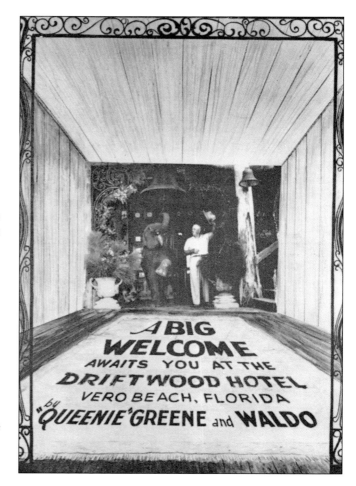

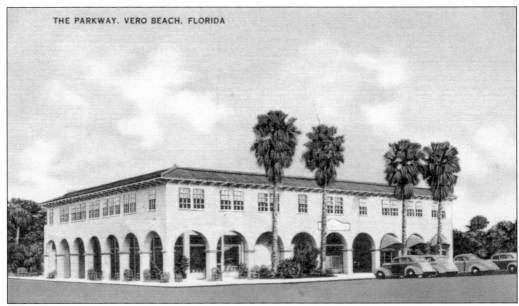

THE PARKWAY. VERO BEACH, FLORIDA

PARKWAY HOTEL, VERO BEACH. From the prosperity and peace following World War II in the 1950s came the growth of the tourist industry, travel by automobile, and the rise of motels and luxurious hotels everywhere. In 1950, the dining room and cocktail lounge at the Parkway Hotel on U.S. 1 were leased to a partnership of Anthony DiPietro, Albert Canata, Dominic Mancini, and Victor Torres. The hotel was completely redecorated, and fancy iron grille-work was added. (Published by Colorpicture; courtesy SMI.)

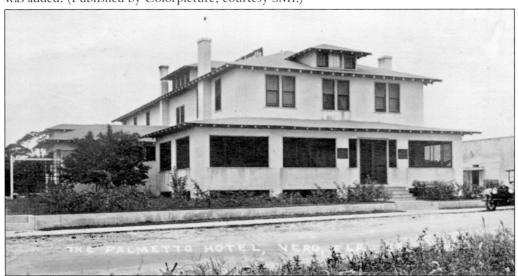

PALMETTO HOTEL, VERO BEACH. The Palmetto Hotel was constructed in 1921 on Dixie Avenue by George W. Gray. It was a social center for the community, and many winter guests returned to it each year. After serving as the county offices, it was subsequently the Kromhout Apartments, the Charlton Apartments, Skippers Inn, and, in 1989, Regent Court Apartments. It is listed in the National Register of Historic Places. (Published by Eastern Illustrating; courtesy of SMI.)

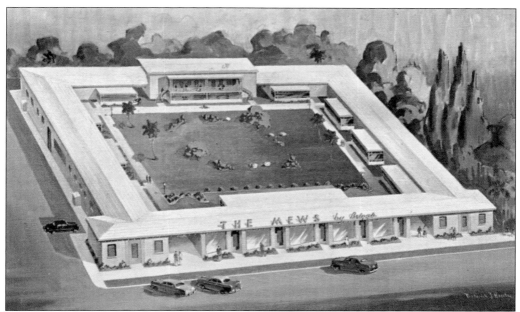

THE MEWS, VERO BEACH. The Mews was developed by Al Briggs as a downtown resort designed for individual privacy with patio apartments and penthouses near shopping centers and five minutes from the ocean. It was advertised with "Charm—Beauty—Convenience—Service. Modern one-bedroom and efficiency apartments—terrazzo floors—tiled baths with tub and shower—electric kitchens—screened porches—air conditioned—T.V." (Published by Hannan Color Production; courtesy SMI.)

THE MEWS. Located at 1825 Fourteenth Avenue, it was named after the famous London Mews section and New York City's Washington Mews apartments, both of which were converted from stables into apartments. This Mews was not. The Mews was still in operation at this address in 1985 and is now the Palm Garden Apartments. (Published by Hannan Color Production; courtesy SMI.)

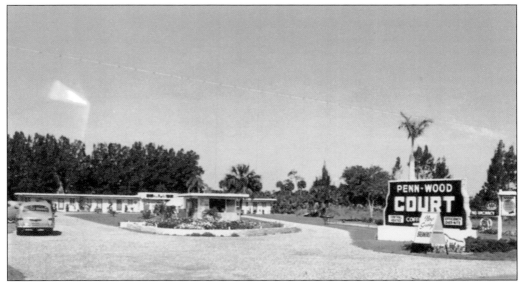

PENN WOOD COURT, WABASSO. The Penn Wood opened prior to 1953 with 22 units, 5 apartments, and a restaurant. It added air-conditioning for the summer months. It boasted of a citrus grove and shuffleboard courts and later added a swimming pool, gazebo, boat parking, clubhouse, and RV park. It is still operating on U.S. 1. (Published by Dexter Press; courtesy SMI.)

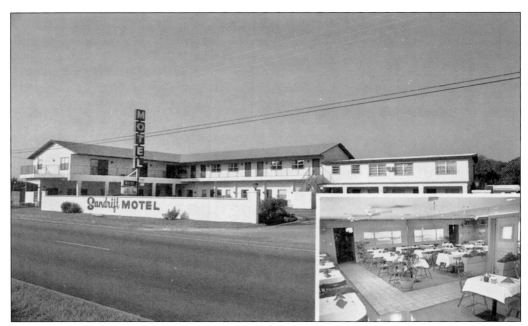

SANDRIFT MOTEL, SEBASTIAN. This family-owned and -operated motel on U.S. 1 in the heart of Sebastian is currently in operation with apartments, efficiencies, a swimming pool, a barbecue area, a restaurant, and a lounge. (Published by H. M. Zalmanoff; courtesy SMI.)

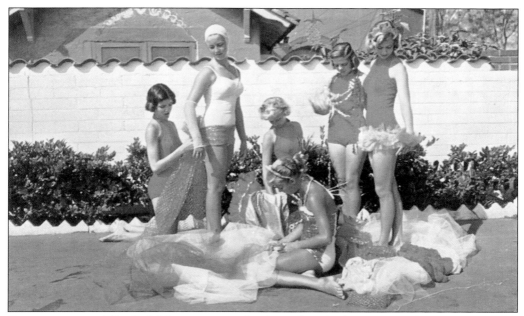

DOLPHINETTES. The Dolphinettes were a local synchronized swim team begun in 1951 as a swimsuit fashion show by Mildred Bunnell, swimming director of the Windswept. During the next 11 years, they gave a Red Cross benefit and performed at Cypress Gardens and in New York. They were featured in several movies. Only high school students with at least a B average could qualify. (Published by F.E.C. News; courtesy SMI.)

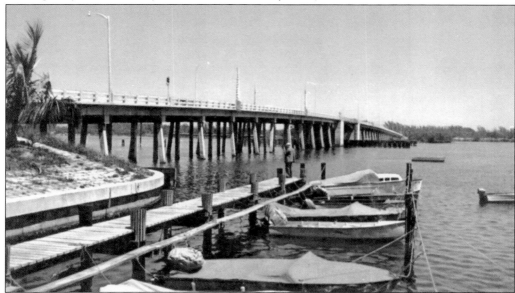

MERRILL BARBER BRIDGE. Vero was the site of the first bridge to cross the Indian River in this area, built in 1920. In 1951, that bridge was replaced with the Merrill Barber Bridge, built near the original. The first bridge at Wabasso was built in 1927. When it was replaced, the 1927 bridge was purchased by Walt Disney Company and relocated to the Magic Kingdom in Orlando. (Published by F.E.C. News; courtesy SMI.)

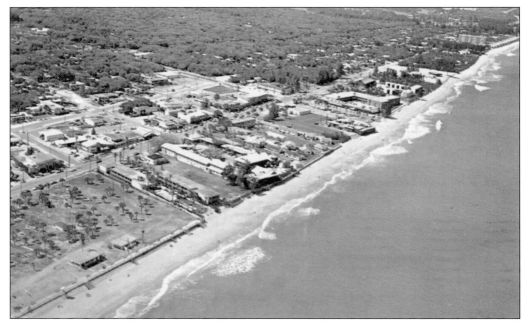

AERIAL VIEW, ATLANTIC OCEAN BEACH. Humiston Park on Ocean Drive, Orchid Island, is in the left foreground. Humiston Park was dedicated in 1953 in honor of Dr. W. H. Humiston, head of the Vero Beach Beautification Society. He was a surgeon from Cleveland who settled in Vero in 1914. (Published by L&M Post Cards; courtesy SMI.)

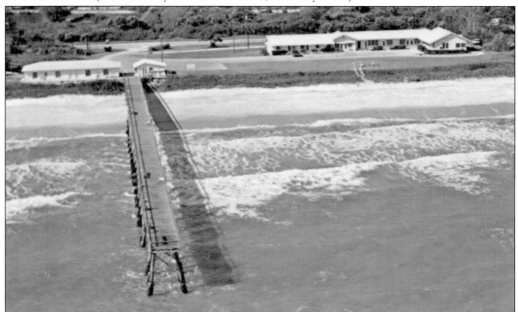

OCEAN FISHING PIER AND MOTEL. The Ocean Fishing Pier and Motel was located at 4800 North A1A. Rooms, efficiencies, and apartments were available on the ocean with access to the fishing pier. Seaquay Condominiums now occupies the space. (Published by Bob Palmer, Dexter Press; courtesy SMI.)

THE BILLOWS AND THE MOORINGS. The Moorings was one of the last dredge-and-fill operations in the state. The property was purchased by Julio Lobo in 1959. Leonor and Jorge de Gonzalez oversaw the development of the property that extends from the ocean to the Indian River Lagoon, with eight miles of seawalls that provide water access for many of the properties. (Published by Dynacolor Graphics; courtesy SMI.)

SEXTON PLAZA. In 1958, the plaza located on the beach at the end of Beachland Boulevard was named Sexton Plaza in honor of Waldo Sexton. There were daylong festivities with a parade, plaque, free barbecue, and dance. With characteristic flair, Waldo had a Spanish treasure chest filled with silver dollars that he threw to parade participants. (Published by D&M Post Cards and Records Company; courtesy SMI.)

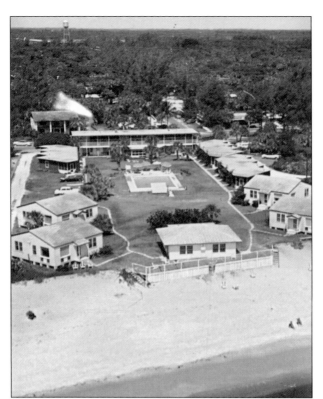

SEA HORSE COTTAGES AND INN. The Sea Horse Cottages and Inn, owned by Sally and C. A. Crawford, were located on oceanfront property between the Ocean Grill and the Driftwood. Subsequent owners razed the buildings and developed Palm Court Hotel, which was heavily damaged in the hurricanes of 2004. Popular Latin songstress Gloria Estefan and her husband, Emilio, renovated and renamed it Costa de Este in 2007. (Published by Wally Skiscim; courtesy SMI.)

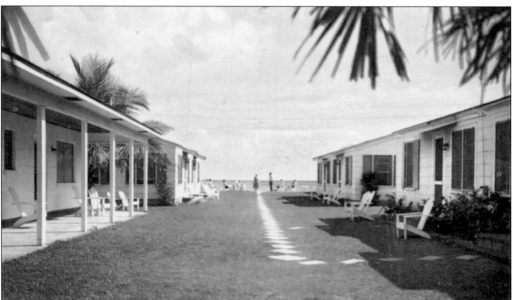

SPINDRIFT COTTAGES. The Spindrift Cottages were located on Ocean Drive next to the Sea Horse Cottages. Owned and operated by Mr. and Mrs. Gayle Smith until 1963, they advertised air-conditioning, electric heat, and television. The Spindrift location became part of the Palm Court Hotel, now the Costa de Este. (Published by L. L. Cook Company; courtesy SMI.)

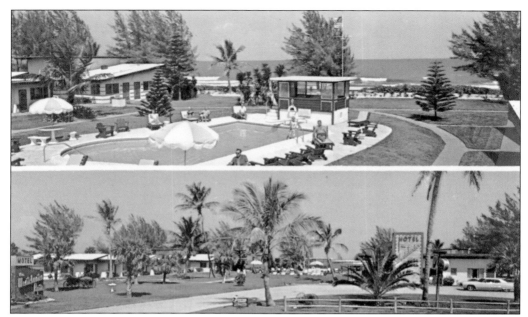

WESTCHESTER APARTMENT MOTEL. The Westchester Apartment Motel advertised a swimming pool, shuffleboard courts, and a golf putting green. The location at 1616 South Ocean Drive is now part of the Sea Cove Condominiums. (Published by O'Brien Color Studios; courtesy SMI.)

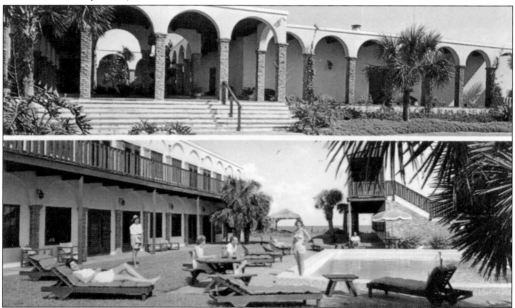

LA POSADA. La Posada was built in 1959 by Claudia and Bill Seagle at 3544 Ocean Drive and was advertised as having old-world flavor and modern comfort. Breakfast in bed was one of the services offered. Currently the Vero Beach Hotel and Club occupies the property, which was expanded in 2007 to include a luxury spa, private beach club, conference center, and condominiums. (Published by O'Brien Color Studios; courtesy SMI.)

83

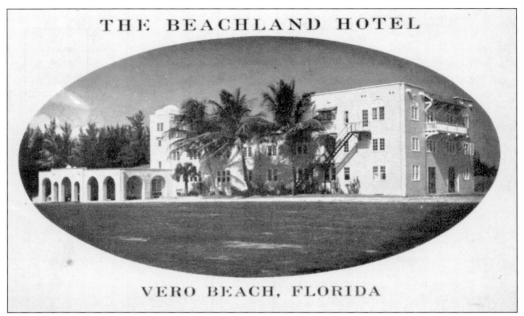

THE BEACHLAND HOTEL

VERO BEACH, FLORIDA

THE BEACHLAND HOTEL/WINDSWEPT/SOUTHWARD. This hotel is shown as the Beachland. From the 1920s, this hotel was a premier vacation destination and a spot for recreation or dining out, combining rooms, a dining room, bar, entertainment, and pool. All rooms had an ocean view. (Courtesy SMI.)

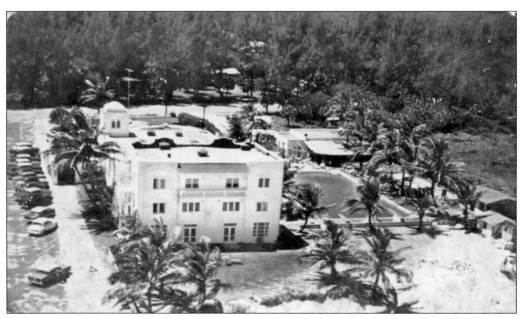

THE SOUTHWARD INN. When it was the Windswept in the 1950s, this inn offered Easter sunrise services. Fellowship breakfast followed, provided by the hotel's management. As the Southward Inn, it had a sister Southward Inn in Orleans, Massachusetts, on Cape Cod. A Holiday Inn is now on this spot. (Published by Bromley; courtesy HS.)

84

JEWELL PALMS HOTEL/ISLANDER. The Jewell Palms opened on Ocean Drive and Camellia Lane in July 1955. Mr. and Mrs. Frank G. Cosentino were the owners, and William G. Taylor, a local architect, designed the building. A coffee shop and pool were among the amenities. (Published by O'Brien Color Studios; courtesy SMI.)

ISLANDER RESORT MOTEL. The Jewell Palms became the Islander, owned and operated by Bud and Mary Lou Belleman. It is still in business as a motel but no longer offers a coffee shop. (Published by Bob Palmer Photography; courtesy SMI.)

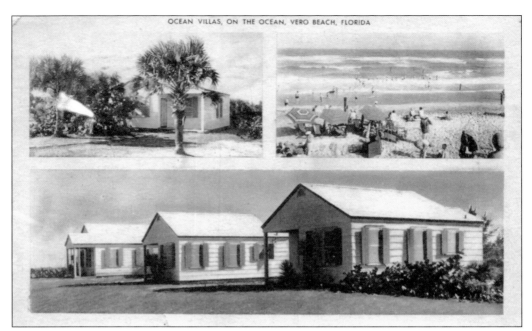

OCEAN VILLAS. From the 1940s through 1982, the Ocean Villas were individual cottage apartments at 2700 Ocean Drive. John T. Ezell was the proprietor through the early 1950s. The Gables Condominium buildings are now in that location. (Courtesy SMI.)

SANDY TOES APARTMENTS. The Sandy Toes Apartments opened early in the 1950s. They were owned and managed by Mr. and Mrs. Tom Bowker and were located on Azalea Lane in Vero Beach. They advertised efficiencies and apartments available by the day, week, or month that had floor-panel radiant heat. Apartments still occupy this space. (Published by Dexter Press; courtesy SMI.)

Eight

BUSINESS AND CIVIC LIFE

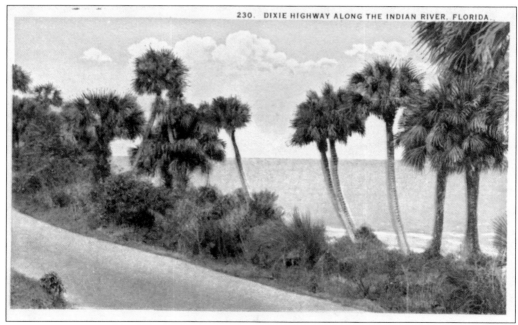

DIXIE HIGHWAY ALONG THE INDIAN RIVER. As the population grew, so did the need for access. Construction of U.S. 1 began in 1921 to connect Vero and Fort Pierce. In 1923, the road between Sebastian and Fellsmere was paved, and a concrete bridge spanning the Sebastian River was built. Between 1925 and 1928, roads throughout the county were improved with macadam, shell, concrete, or dirt. (Published by Asheville Post Card Company; courtesy SMI.)

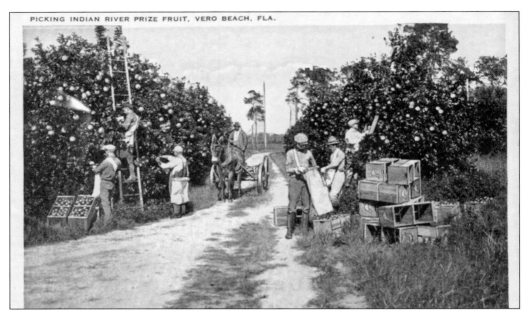

INDIAN RIVER GROVES. In the 1920s, acreage under cultivation and the quality of fruit produced by the Gifford, Graves, Helseth, Michael, and Sexton families ensured that the Indian River area would become noted as the world center of citrus production. Rainey Duncan became president of the Indian River County Citrus Growers Association. (Published by Tichnor Quality Views; courtesy SMI.)

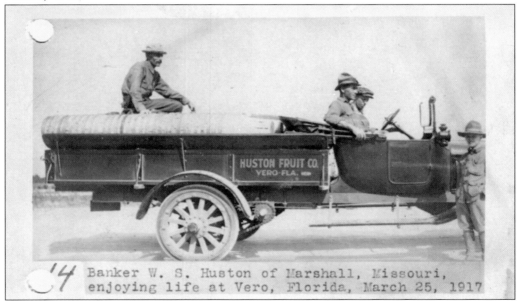

BANKER W. S. HUSTON OF MARSHALL, MISSOURI, ENJOYING LIFE AT VERO, 1917. Agriculture formed the backbone of the local economy in its formative years. People from many disparate occupations became farmers and growers in Indian River County, as did this banker from Missouri. His Huston Fruit Company truck is carrying produce to the packinghouse. (Published by Commercial Photographic; courtesy HS.)

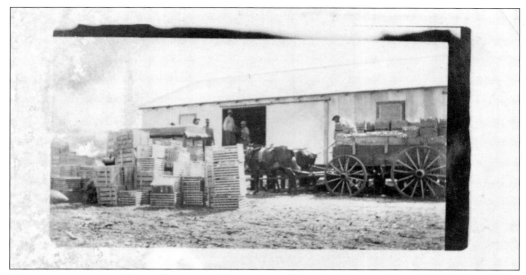

PACKINGHOUSE AT VERO SHIPPING POTATOES. Organized promotion of the Indian River County area for residential and agricultural purposes began very early. George T. Tippin, an experienced businessman, spoke to the Indian River Growers Association regarding the importance of cooperative marketing practices during its formative period in 1914. During that same year, the association built a packinghouse and shipped its first carload of tomatoes by train. (Courtesy HS.)

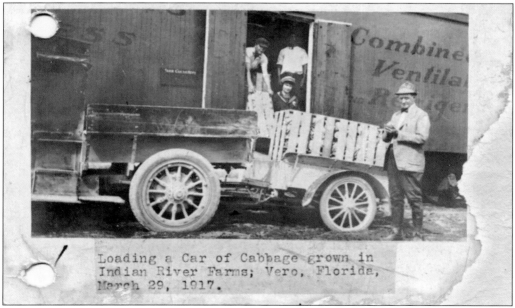

LOADING A CAR OF CABBAGE, 1917. Indian River Farms cabbages are loaded on a train heading north. Railroads proved to be a more efficient mode of transport than steamship, and by 1898, citrus growers complained about high shipping rates. In 1899, Henry Flagler was said to have written "nothing competes with Florida oranges but Florida oranges—an advance in rates always comes out of the pocket of the consumer." (Published by Commercial Photographic; courtesy HS.)

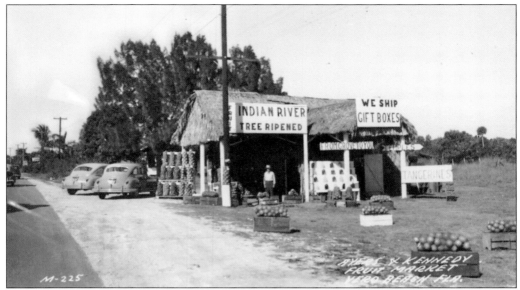

AYERS AND KENNEDY FRUIT MARKET. Frank Ayers set up a roadside stand with his nephews, the Kennedy brothers Pernell and Tom, in the mid-1940s on north U.S. 1 in a palmetto shack. Working together, local grove owners used their expertise to develop the "brand idea" of marketing, and by 1930, the Indian River Citrus League had built customer loyalty to the Indian River citrus products brand. (Published by L. L. Cook Company; courtesy AC.)

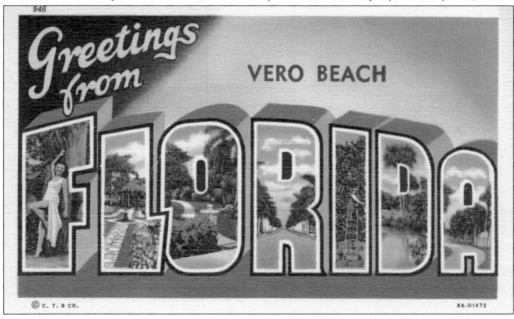

GREETINGS FROM VERO BEACH, FLORIDA. In 1914, the Vero Board of Trade was established with three vital projects in mind: incorporation of Vero, a telephone exchange, and a canning factory. A vigorous campaign was begun in 1915 to attract new businesses to the area. By 1915, the board of trade was advertising Vero as a vacation spot as well. By 1919, Vero was incorporated. (Published by Florida Post Card Company; courtesy SMI.)

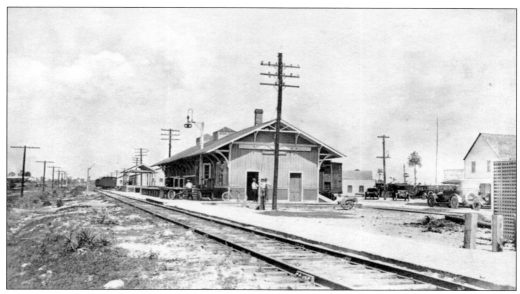

VERO BEACH DEPOT. After Henry M. Flagler left Standard Oil, he wintered in the late 1880s in St. Augustine, Florida. Seeing possibilities for a new business venture, Flagler organized the Florida East Coast Railroad (FEC), which brought winter visitors, land speculators, and new residents to Florida. For several years, Vero was a "whistle stop," or a flag station, for the FEC. By 1936, scheduled stops were made at the new Vero Beach Depot. (Courtesy HS.)

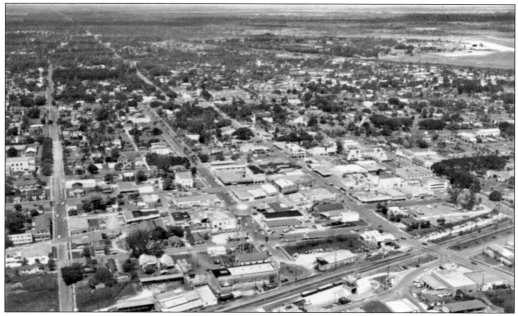

AERIAL VIEW OF VERO BEACH. Rapid growth brought ever-increasing power demands. Prior to 1920, the Vero Utilities Company shut off current at midnight, and the only daytime electricity was Wednesday afternoons for ironing. The engines stalled frequently as well. The power demands required numerous system upgrades from 1920 onwards. The old power plant is listed in the National Register of Historic Places. (Published by F.E.C. News; courtesy SMI.)

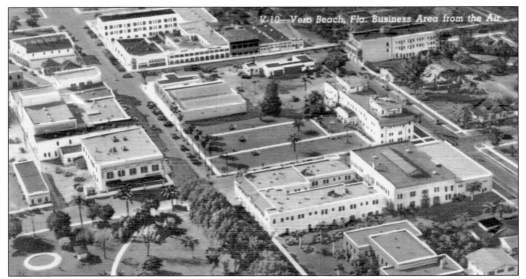

VERO BEACH FROM THE AIR. On November 26, 1930, Mayor Alex MacWilliam issued a proclamation naming the week of December 1 "Clean-Up Week" and declared Friday, December 5 "Beautification Day" and a legal holiday. All citizens were urged to "lend their individual aid and assistance toward city beautification" to prepare the city for winter visitors and make the city a more beautiful place in which to reside. (Published by Florida Card and Novelty Company; courtesy HS.)

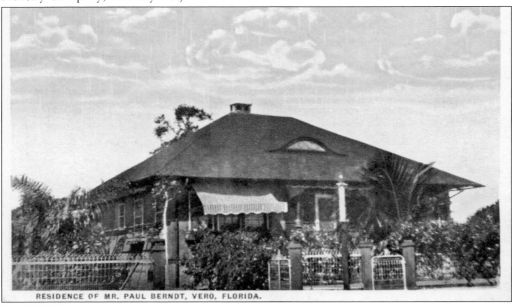

RESIDENCE OF MR. PAUL BERNDT, VERO, FLORIDA.

BERNDT RESIDENCE. Following devastating hurricanes in 1926 and 1928, the Florida State Chamber of Commerce organized Picture Postcard Week to help bolster the state's image. The Vero Beach Chamber of Commerce was assigned October 1928. Area residents, including schoolchildren, were encouraged to send cards such as this view of the Berndt residence to out-of-state friends and relatives extolling the virtues of Florida and Vero Beach. (Published by Asheville Post Card Company; courtesy SMI.)

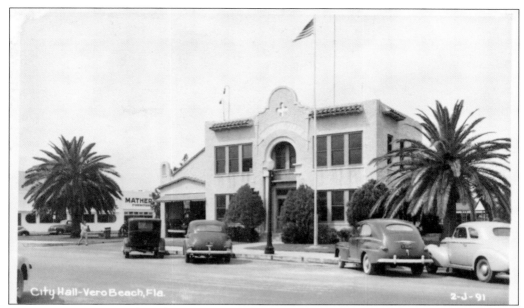

CITY HALL, VERO. When the new city hall building was completed in April 1924, the mayor, city clerk, president of the city council, and two ex-mayors were taken to the new city hall, "arrested," and "fined" a total of $41.16, which was given to the Vero baseball club. After this prank, they all adjourned to the second-floor council chamber for the first meeting in the new city hall. (Courtesy SMI.)

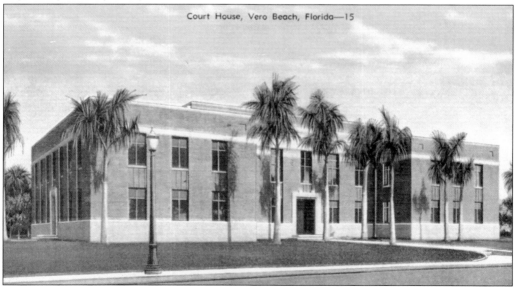

INDIAN RIVER COUNTY COURTHOUSE, VERO BEACH. In 1933–1934, James T. Vocelle was instrumental in seeking federal funding for the county's courthouse located on Fourteenth Avenue in Vero Beach, pictured here. In 1995, a new courthouse was built at Sixteenth Avenue, near Twentieth Street, because of the need for more room. The old courthouse was converted into the courthouse executive center and is listed in the National Register of Historic Places. (Published by E. C. Kropp Company; courtesy SMI.)

93

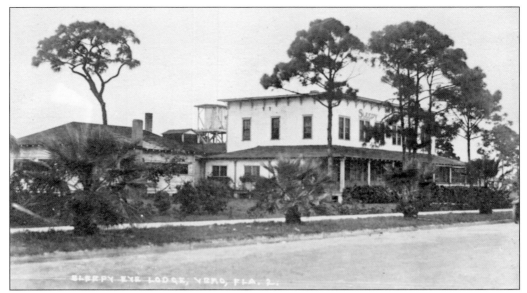

FIRST LIBRARY IN VERO: SLEEPY EYE LODGE. Although plans had been started for a proper library, Mrs. Irene Young decided that the library need not wait for the commencement of building of the woman's center/library. Two porches of the Sleepy Eye Lodge were outfitted with shelves for a library and a reading room in the summer of 1915. (Published by Eastern Illustrating Company; courtesy SMI.)

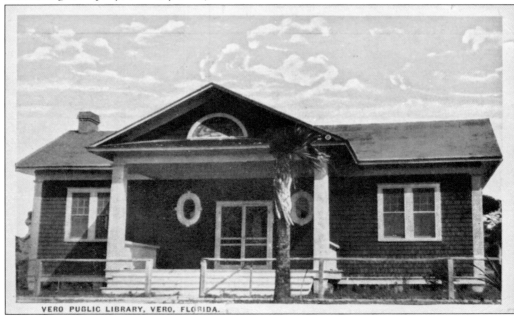

SECOND LIBRARY IN VERO: WOMAN'S CLUB. Twenty-seven women met February 16, 1915, at Irene Young's home to organize a Woman's Club and a public library. Mrs. Hard donated 300 books to start the library. Waldo Sexton donated cypress and black walnut for tables and desks. The building is still used for meetings and events and is listed in the National Register of Historic Places. (Published by Asheville Post Card Company; courtesy SMI.)

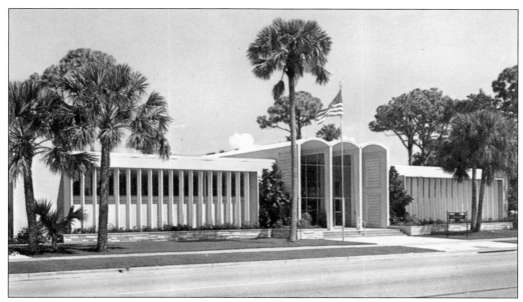

THIRD LIBRARY IN VERO BEACH. The Indian River County Library Association was formed in 1958 to provide for a larger county-wide library. In two years, the association developed a plan, obtained land at 1028 Twentieth Place from the city, and solicited funds from residents, businesses, and winter visitors. Preservation of archival records was a prime consideration. Eventually the county took over financing. (Published by D&M Post Cards and Records Company; courtesy HS.)

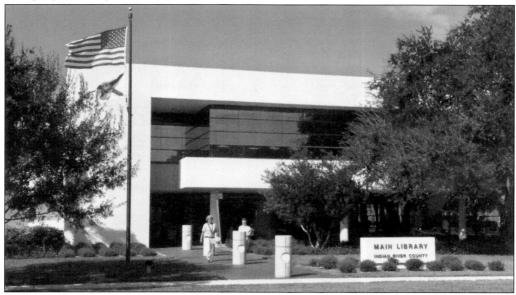

FOURTH LIBRARY IN VERO BEACH: INDIAN RIVER COUNTY MAIN LIBRARY. In 1989, county commissioners approved plans for a new library in downtown Vero Beach, adding a new courthouse and parking garage nearby in an effort to revitalize downtown. It was completed on February 1, 1991. The new site at 1600 Twentieth Street replaced the Grace Lutheran Church and two businesses. (Published by Coastal Graphics; courtesy SMI.)

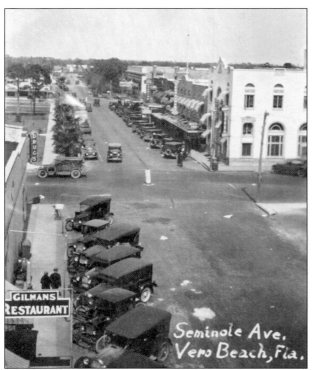

SEMINOLE AVENUE, VERO BEACH. Originally built in 1926 in the Mission/Spanish Revival style, the Pueblo Arcade is located at 2044 Fourteenth Avenue (Seminole Avenue). Arcades with shop doorways opening into a hallway were very popular prior to the introduction of air-conditioned malls. This arcade was restored by developer Robert L. Brackett and is listed in the National Register of Historic Places. (Courtesy SMI.)

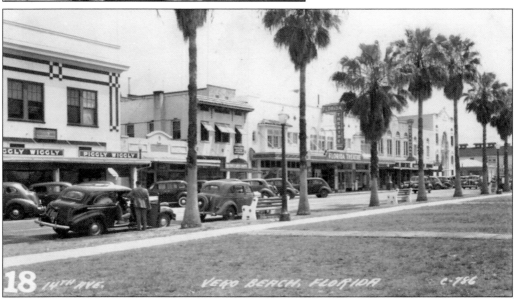

FOURTEENTH AVENUE, MOVIE THEATER, VERO BEACH. The Florida Theater, located on Fourteenth Avenue, opened October 20, 1924. Within a year, it became the center of the fight to remove Indian River from St. Lucie County because of enforcement of local blue laws prohibiting Sunday film viewing. Gov. John W. Martin created Indian River County in May 1925. Now the Theatre Plaza, it is listed in the National Register of Historic Places. (Published by L. L. Cook Company; courtesy HS.)

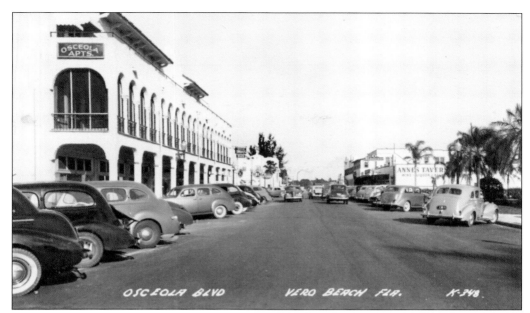

OSCEOLA BOULEVARD (TWENTIETH STREET), VERO BEACH. The middle of Osceola Boulevard looking east is shown in this postcard. On the left are the Osceola Apartments, Hague Drugs, and the bus stop at the end of the block. On the right are Anne's Tavern, Jun's Grocery, and Friedlander's. Decades before Vero Beach had its first shopping mall, area residents often met friends and shopped in the downtown stores. (Published by L. L. Cook Company; courtesy SMI.)

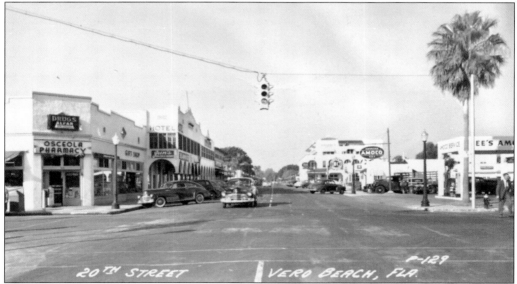

OSCEOLA BOULEVARD, VERO BEACH. Vero Beach's bustling downtown is depicted on this card looking west. The fire that destroyed the wooden buildings on Osceola Boulevard in 1919 resulted in a new, modern look for the street when Henning and Meyer purchased Lot 7, Block 49, in 1920 and rebuilt. In 1922, Keffer's Pharmacy opened on the corner. On February 15, 1929, it reopened as Osceola Pharmacy with Iris Keffer as manager. (Courtesy CHI.)

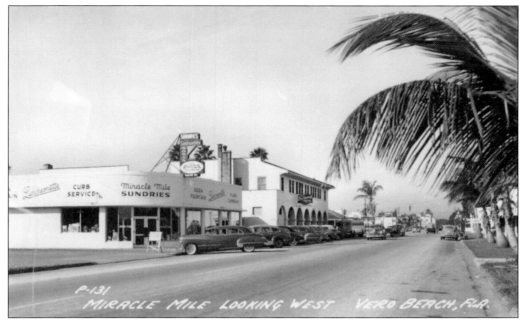

MIRACLE MILE, VERO BEACH. Shown is Miracle Mile Sundries, with curb service. When the Miracle Mile Plaza was developed in the early 1960s, it was viewed as a threat to downtown business. However, it relieved the traffic congestion in the downtown area. It was the area's first large shopping center. (Published by L. L. Cook Company; courtesy SMI.)

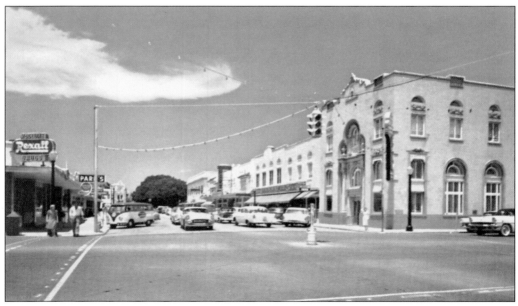

DOWNTOWN VERO BEACH, FARMER'S BANK. James Hudson Baker and family moved to Vero Beach in 1912. He was a building contractor responsible for the building of the Vero Theatre Building and Farmer's Bank Building (shown on the right). He was nominated to the Great Floridians 2000 Program. (Published by the F.E.C. News; courtesy SMI.)

SWAGATAM IMPORTED GIFTS. Interesting, exotic goods lured tourists to spend with this interior shot of Swagatam: "Brass, wood carvings, bronze tableware, straw bags, jewelry, exotic fabrics and other interesting and unusual gifts from India, Nepal, Persia, Taiwan, Japan, Hong Kong, the Philippines, Israel, Italy, Germany, Norway, Austria, England, Morocco, Mexico." It is now Kane's Appliances at 940 Miracle Mile. (Published by Dukane Press; courtesy SMI.)

L. N. DELLERMAN PLUMBING AND ELECTRICAL COMPANY, VERO BEACH. Dellerman's, the oldest plumbing firm in Vero Beach, took a light-hearted approach to advertising. One advertisement in 1924 reads: "When ladies wear their skirts above their knees, the police should send them to the plumber. It's our business to cover joints properly." Dellerman's received the contracts for both the wiring and plumbing of the new theater in that year. (Published by O'Brien Color Studios; courtesy SMI.)

SEBASTIAN, FLORIDA. Sebastian has been both a destination and an embarkation point. In 1919, the Fellsmere Railroad Company ran a train between Sebastian and Fellsmere, a distance of 9.94 miles, twice daily except Sunday, powered by a wood-burning steam locomotive. The railroad was extended to include the area named Broadmoor, created in 1913, in order to facilitate buyer access to the Demonstration Farm. (Published by Colourpicture Publishers; courtesy SMI.)

WABASSO, FLORIDA. Capt. Frank Forster planted the first citrus grove in the Wabasso area in the 1880s. The railroad reached Wabasso in 1893, and the post office opened in 1898. In 1925, Wabasso residents decided that it was necessary to incorporate the city. After making local improvements and deeding land for a power station, it was decided that nothing further could be accomplished, and the city unincorporated in 1933. (Published by Parco Card Company; courtesy SMI.)

Nine

SPIRIT AND MIND

GRACE METHODIST EPISCOPAL CHURCH AND PARSONAGE, WABASSO, 1925. The Methodist Episcopal Church sent Rev. Emory Getman to serve the area's spiritual needs in the early 1880s. He traveled by boat and held services in homes and schoolhouses. For some time, the Methodist church was the only church in Wabasso, and all denominations attended—Baptists, Episcopalians, Catholics, and Dunkards. The church served as the social center as well. (Published by Azo; courtesy VAN.)

GRACE METHODIST EPISCOPAL CHURCH, WABASSO. Wabasso's Methodist Episcopal church was organized in 1917 as a result of two spirited revivals and with the help of C. A. Vandiveer. The Grace Methodist Episcopal Church stood across the street from the Vandiveer house. It closed in 2003. The car at the far right is the first car in Wabasso, owned by Will and Allie Early. (Published by Azo; courtesy VAN.)

ROSELAND GARDENS COMMUNITY CHURCH. In July 1957, a building permit was issued, and a dedication ceremony on February 2, 1958, officially opened the Roseland Gardens Community Church with Rev. Denny R. Hendry presiding. Roseland acquired its name in 1892 from roses grown by the Cain family when Will Underwood, a Mallory brother, and Dempsey Cain applied for a post office. (Published by Bob Palmer Photography; courtesy HS.)

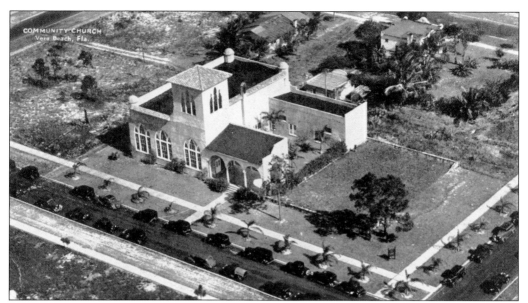

COMMUNITY CHURCH, VERO BEACH. The Community Church had its beginnings in a small group that met first in homes, then in the Woman's Club in the early 1920s. Community Church was established in 1924 at 1901 Twenty-third Street. The new building was dedicated on November 13, 1955. There were 83 charter members. Many of its records were destroyed in 1960 from an unknown cause. (Published by Aerographic; courtesy SMI.)

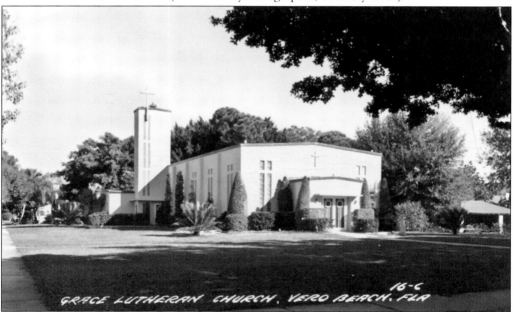

GRACE LUTHERAN CHURCH, VERO BEACH. The Grace Lutheran Church was established on Seventeenth Avenue by a group of men who met at one of their homes in February 1917. Their first chapel, which seated 65 worshippers, was built in 1919. The first full-time pastor, the Reverend A. R. Frederking, arrived in 1929. The parish has moved twice as it expanded its congregation and facilities. It moved to 1150 Forty-first Avenue in 1988–1989. (Courtesy SMI.)

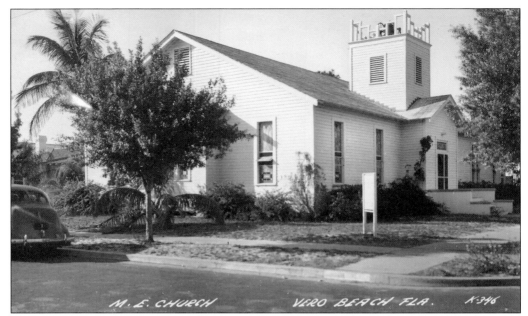

METHODIST EPISCOPAL CHURCH, VERO BEACH. Originally the Baptists and Methodists alternated services in the school building, and a community Sunday school was organized. In 1914, the Indian River Farms Company deeded two lots at Mohawk Avenue and First Street (Sixteenth Avenue and Twenty-first Street) for a church and parsonage. The church was built some time after April 1915. (Courtesy SMI.)

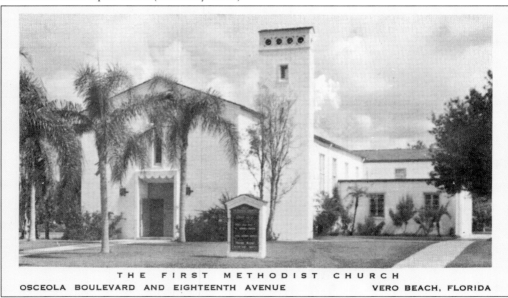

FIRST METHODIST CHURCH, VERO BEACH. In 1914, the Methodists in Vero held two weeks of revival meetings. First Methodist Church was established in 1914 at Sixteenth Avenue and Nineteenth Street. The new sanctuary was opened in February 1951, and in 1952, it was moved to 1750 Twentieth Street. In 1965, it merged with the Evangelical United Brethren Church and became the First United Methodist Church. (Published by Spalding Publisher; courtesy SMI.)

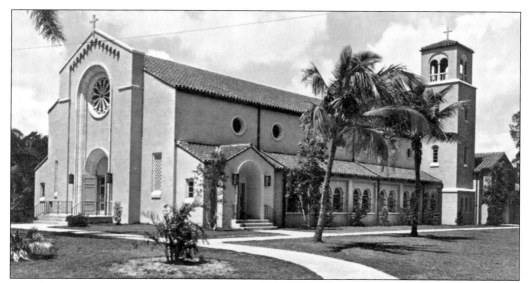

ST. HELEN CATHOLIC CHURCH, VERO BEACH. St. Helen was the first Catholic church in Indian River County. Around 1914, Rev. Fr. Augustine P. Heinmann, pastor of a Kansas Catholic church, moved to Vero with several families of his church. The first services were held in the home of Louis Schlitt on Twenty-second Avenue. The church proper was established at 2085 Tallahassee Avenue in December 1919. The present church was built in the early 1950s. (Published by Curteich Color; courtesy SMI.)

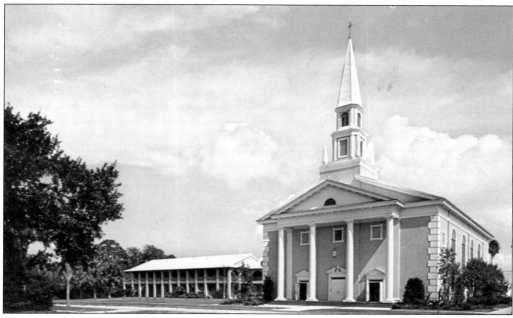

FIRST BAPTIST CHURCH, VERO BEACH. The First Baptist Church, originally known as the Vero Baptist Church or Pioneer Baptist Church, was founded in Vero in 1915 with 15 charter members. A church-raising bee was held on December 3, 1915. It was built on two lots donated by the Indian River Farms Company. It became the First Baptist Church at 2206 Sixteenth Avenue in 1935. (Published by D&M Post Cards and Records Company; courtesy SMI.)

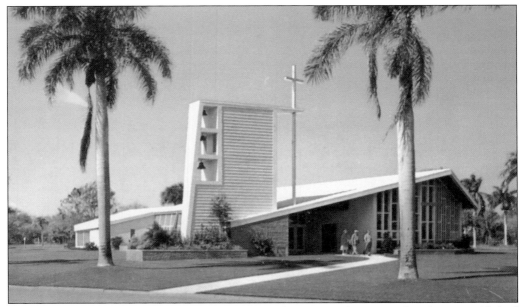

FIRST PRESBYTERIAN CHURCH, VERO BEACH. The First Presbyterian Church was established in 1954 at 520 Royal Palm Boulevard. The sanctuary was completed in June 1955. At the end of the first year, there were 167 members. The buildings at Royal Palm Place and Royal Palm Boulevard have increased with the erection of a chapel, fellowship hall, lounge, educational facilities, and offices. (Published by Curteich Color; courtesy SMI.)

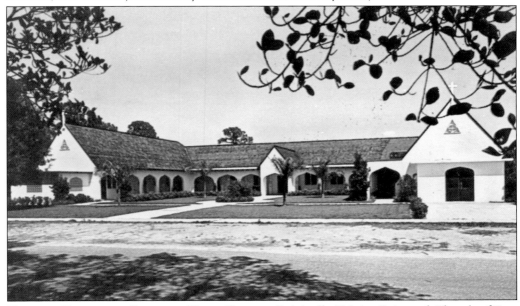

TRINITY EPISCOPAL CHURCH, VERO BEACH. Originally Trinity Episcopal Church of Fort Pierce, the first service of the Trinity Episcopal Church was held in 1926 in the Woman's Club. Although the ground-breaking ceremony was held in 1927, the first service was not held in the new church until June 1931. Adelaide Teele Zeuch remained a staunch supporter of the parish after the death of her husband, Herman, in 1937. (Published by Bob Palmer; courtesy SMI.)

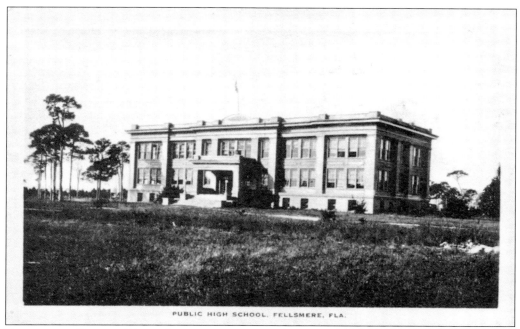

PUBLIC HIGH SCHOOL, FELLSMERE, FLA.

FELLSMERE PUBLIC HIGH SCHOOL. In 1912, school enrollment had reached 60 children, and the two-room schoolhouse was outgrown. In 1915, a three-story brick schoolhouse was built. It was the first school building designed by noted architect Frederick Trimble and is listed in the National Register of Historic Places. Although it closed in 1982, a local effort to restore it as a multi-purpose building has been proposed. (Published by Frank X. Oliver, Hotel Fellsmere; courtesy SMI.)

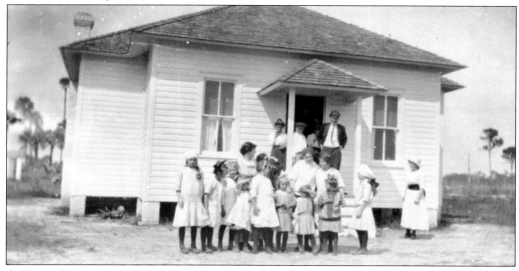

A VERO SCHOOL C. 1914–1915. Vero had a population of less than 40 people when it built its first school in 1906 on land donated by Henry Gifford on Twentieth Street between Eighth and Ninth Avenues. Its one room became a community gathering spot, including Christmas celebrations. It was outgrown, and the building was sold and become a movie theater; on Saturdays, square dances were held there. (Courtesy HS.)

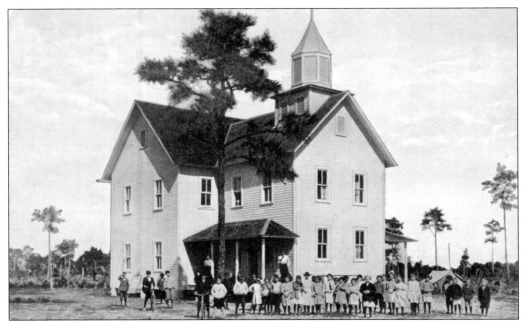

A NEW VERO SCHOOL C. 1914. This postcard was used as an advertisement by Indian River Farms Company. On September 21, 1914, the Vero school year opened with 73 students, and the Walker School began with 7 pupils. The old Vero School building was used until the new one was completed. Land for the school was donated by the Indian River Farms Company. (Published by L. B. Kopp; courtesy HS.)

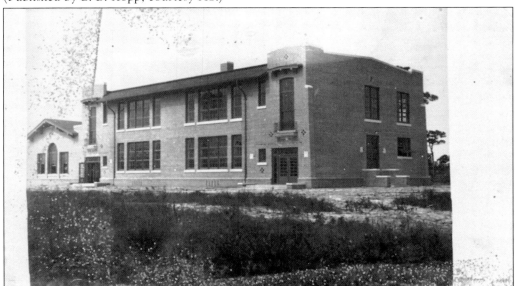

OLD ELEMENTARY SCHOOL, NINETEENTH STREET AND FIFTEENTH AVENUE, VERO. When it was completed, the Vero Beach Elementary School was called one of the finest in the state. It was a two-story example of Spanish architecture, with buff brick trimmed in green. It had a spacious auditorium and library. On September 15, 1919, opening exercises were held in the Methodist church across the street, as the auditorium was not quite finished. (Courtesy HS.)

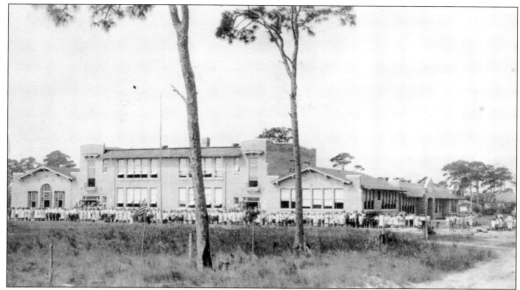

VERO BEACH ELEMENTARY SCHOOL. In the fall of 1925, through the efforts of the Aladdin Club, a cafeteria was added to the school. The club raised funds and worked gratis in the cafeteria during the start-up period. By the end of the school year, the club turned the cafeteria over to the school board along with cash they had raised. By 1929, there were 430 pupils. (Courtesy HS.)

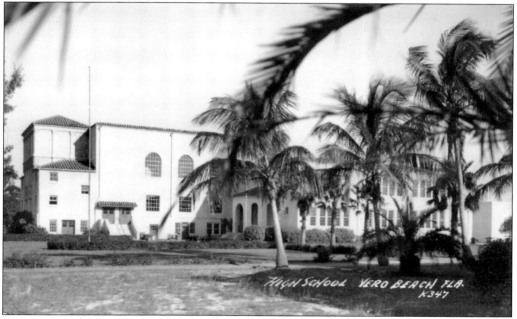

VERO BEACH HIGH SCHOOL. The Vero Beach High School was built in 1925. The Spanish-style building had two wings. A fountain was built as a memorial by students in the late 1920s. The building was located at the site of the current Freshman Learning Center. A granite monument has been placed to commemorate the building that was replaced in 1964 by the current high school. (Published by L. L. Cook Company; courtesy SMI.)

HARRIS SCHOOL, VERO. The Harris School was built around 1915 near the corner of Glendale (Eighth Street) and Clemann (Forty-third Avenue). After completion, it was used by the Lutherans for their services. They were later responsible for the establishment of the Grace Lutheran Church in 1917 and Community Church in 1924. (Published by Noko; courtesy SMI.)

SUNDAY SCHOOL CLASS, HARRIS SCHOOL. This card depicts the Lutheran Sunday school class at Harris School, May 6, 1917. Louis Harris was a school trustee of the district. (Courtesy HS.)

Ten

SUN, SAND, AND ENTERTAINMENT

GREETINGS FROM VERO BEACH, FLORIDA. This card emphasizes the primary tourist attractions of the area: sunshine, great weather, Indian River boating, fishing, parks, and ocean beaches. Treasure hunting in the ocean waters is still a popular hobby. Marinas, yacht clubs, and parks are available. Waterfront homes and temporary lodging on the beaches provide access. Shuffleboard was an early favorite pastime; golfing is a perennial favorite. (Published by Colourpicture Publishers; courtesy SMI.)

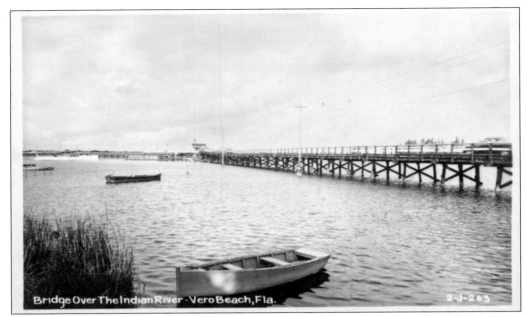

Bridge Over The Indian River - Vero Beach, Fla. 2-J-283

BRIDGE OVER THE INDIAN RIVER, VERO BEACH. Bridges have spanned the Indian River at Vero Beach continuously since the first one was erected in 1920, providing access to the barrier island and ocean beyond. Vero Beach now has two bridges, the Merrill Barber Bridge and the Seventeenth Street Bridge. The first bridge at Wabasso was built in 1927, and the first bridge at Winter Beach was built in 1924. (Courtesy SMI.)

MERRILL P. BARBER BRIDGE, VERO BEACH. Merrill P. Barber was founder, director, and later president of Indian River Citrus Bank, from 1935 to 1975. From 1947 to 1949, he was mayor of Vero Beach. He was a member of the Florida State Road Board and the Florida Senate. He has been nominated to the Great Floridians 2000 Program. This bridge, constructed in 1951, was named in his honor. (Published by Dexter Photo Service; courtesy SMI.)

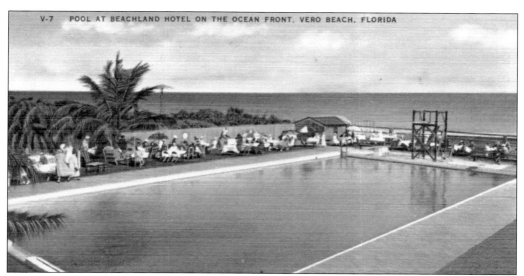

POOL AT THE BEACHLAND HOTEL ON THE OCEANFRONT. Following a nationwide trend, the Beachland Hotel and other Indian River County hotels added swimming pools, even on the beach. The Beachland pool was filled by pumped-in ocean water. In the 1960s, Driftwood manager Tony Watts added a pool, a move that increased the Driftwood's popularity. (Published by Hartman Litho Sales Company; courtesy HS.)

YACHTING ON THE INDIAN RIVER.
Yachting is one of the many reasons people come to Indian River County and write home about it. (Courtesy HS.)

113

MUNICIPAL DOCK ON THE INDIAN RIVER, VERO BEACH, 1940s. From its earliest days, access to the Indian River has been a civic consideration. In 1914, the need for a public dock was on the agenda at the board of trade meetings. During World War II, the dock was used by the Naval Air Station as part of air and sea rescue missions. (Published by Hartman Litho Sales Company; courtesy SMI.)

Yacht Club Park and Docks on the Indian River, Vero Beach, Florida

YACHT CLUB PARK AND DOCKS ON THE INDIAN RIVER, VERO BEACH. Vero Beach Yacht Club was chartered in 1926. Prescott Gardner was a charter member. The yacht club operated the city docks from 1938 to 1970. A new pier was added in 1946. Its clubhouse opened in June 1963. (Published by Eli Witt Company; courtesy SMI.)

REGAL DELUXE MOTEL
On U. S. 1 South
Vero Beach, Florida
Phone 6524
Shuffleboard, Bowling, 2 Golf Courses, Movies and Finest
Unrestricted beach in Florida 1 mile, picnic facilities.
Large Family units, twin and double Beautyrest beds.
100% Air-conditioned, Central heat, TV in rooms. Winter
home of Brooklyn Dodgers. Fine fishing, hunting, skiing.
Owner-Managed by the Michelettis

POST CARD

Address

Dear Friends:
We are enjoying
the warm weather &
Roy is fishing everyday
and eating fish too.
flowers are in bloom
so makes thing look like
spring. especially after our
cold spell. Happy
New year to all from
both of us. Roy & Ag.

Mr & Mrs Joe Rhode
E. Jefferson St
Freeport
Illinois .

A Winter Vacation to Write Home About. As depicted above, this card reads: "Dear Friends: We are enjoying the warm weather and Roy is fishing every day and eating fish too. Flowers are in bloom so makes things look like spring, especially after our cold spell. Happy New Year to all, from both of us." (Published by O'Brien Color Studios; courtesy SMI.)

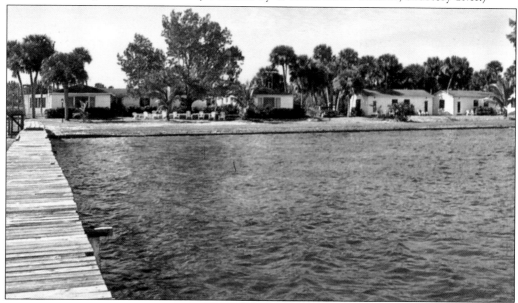

Indian River Cottages, Wabasso. The Indian River Cottages offered efficiency apartments and cottages on the river. A landing ramp and mooring docks were available for visitors, who could either bring their own boat or rent one. A 175-foot fishing pier extended into the river. The county is noted for its variety of fish species found in the Indian River Lagoon. (Published by Bill Bennett Studios; courtesy of SMI.)

FISHING ON THE ATLANTIC OCEAN. Saltwater fishing from the beach or deep-sea sport fishing in the Atlantic Ocean off the roughly 22 miles of coast of Indian River County brings annual visitors. Blue Cypress Lake, the Indian River Lagoon, St. Sebastian River, and St. Johns River tributaries all provide freshwater fishing. Sebastian Inlet, noted for its fishing, has remained open since 1948. (Published by Curteich; courtesy SMI.)

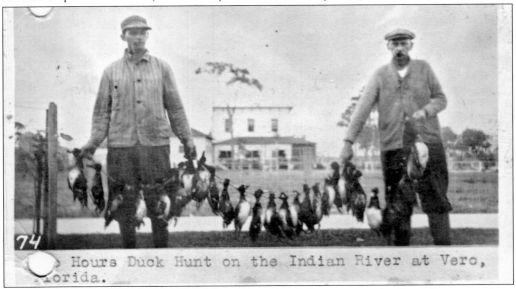

Hours Duck Hunt on the Indian River at Vero, Florida.

DUCK HUNT ON THE INDIAN RIVER. The rivers, marshes, and wetlands of the county have provided spectacular hunting and fishing from the earliest times, whether for sport, food, or commerce. Thousands of acres of marshland and wetlands allow hunting in season under the management of the Florida Fish and Wildlife Conservation Commission and the St. Johns River Water Management District. (Published by Commercial Photographic Company; courtesy HS.)

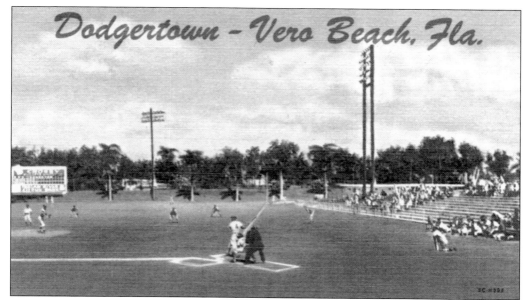

DODGERTOWN, VERO BEACH. After more than a half-century of occupancy, in 2001, the Dodgers began negotiations to leave Vero Beach. A new lease was signed, but in 2006, the team again made the decision to relocate to another training site. Numerous uses for the facilities have been proposed, including attracting another team, using the area as a sports complex or park, or development. (Published by F.E.C. News; courtesy HS.)

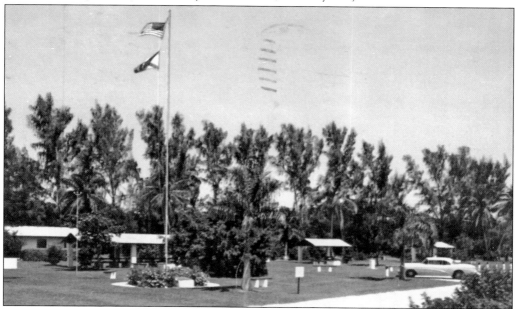

ALEX MACWILLIAM PARK. The many accomplishments of Alex MacWilliam include designing and building Riomar. He was a justice of the peace, a mayor of Vero Beach, and a delegate to the Florida House of Representatives, and he was instrumental in the creation of Indian River County. Pocahontas, Young, and Hummiston Parks exist because of his efforts. He is on the Great Floridians list. (Published by F.E.C. News; courtesy SMI.)

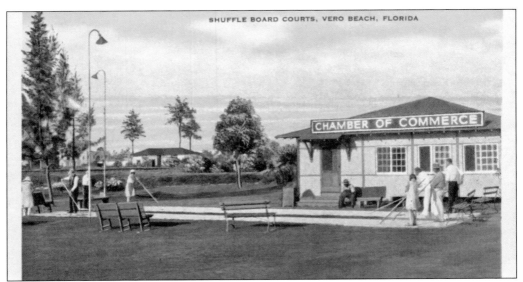

SHUFFLEBOARD COURTS, CHAMBER OF COMMERCE, VERO BEACH. By the 1920s, all of the first-class hotels in the East had shuffleboard courts. Entrepreneurs in Indian River County followed suit by providing many courts in the area, such as this one at the Chamber of Commerce Building in Pocahontas Park. The park also boasted of a small zoo, children's playground, baseball diamond, horseshoe court, and tennis court. (Published by E. C. Kropp Company; courtesy SMI.)

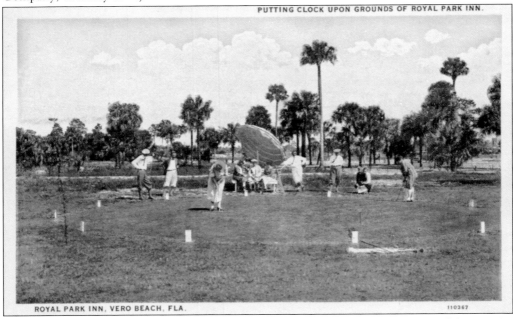

ROYAL PARK INN, VERO BEACH, FLA.

110367

PUTTING CLOCK, ROYAL PARK INN, VERO BEACH. The Royal Park Inn, one of the premier hotels in the area, had many amenities for its guests. In addition to this putting clock, it offered a full golf course, trap shooting, fishing, riding, surf bathing, hunting, a horseshoe court, shuffleboard court, and the "best Northern Cuisine." (Published by Asheville Post Card Company; courtesy SMI.)

DINING ROOM, ROYAL PARK INN, VERO BEACH. Built in 1924, the dining room of the Royal Park Inn was a very popular spot in the 1930s for residents and guests alike thanks to its excellent cuisine. (Published by Albertype Company; courtesy SMI.)

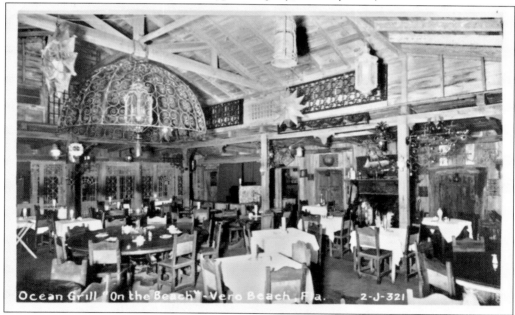

OCEAN GRILL ON THE BEACH. The Ocean Grill opened December 31, 1941, as a fine restaurant on Florida's Atlantic coast. It had the signature appearance of a Waldo Sexton creation, with an eclectic mix of materials including the world's second largest round table, made from a solid piece of mahogany. After the war, the restaurant was known to the locals as the Bucket. It currently remains one of the finest restaurants in town. (Courtesy SMI.)

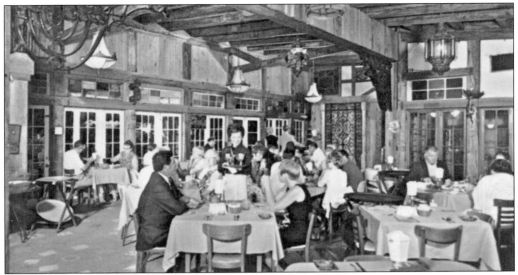

PATIO RESTAURANT, VERO BEACH. Created by Waldo Sexton, the Patio Restaurant opened originally in 1935 as a fruit stand, closed during World War II, and reopened as an open-air restaurant in late 1950s. True to Sexton's signature, the restaurant contains wood walls, wrought-iron grille-work, and very old Spanish and French tiles. Behind the bar in the cocktail lounge are hand-carved wood panels from sections of Lebanese bridal chests. (Published by Dick Deutsch; courtesy SMI.)

BLUE GOOSE. Blue Goose was the Vero Beach–based gift package plant for American Fruit Growers. Its building on U.S. 1 also featured a juice bar. In 1948, for its inaugural New York–Miami flight, Eastern Air Lines' Constellation-class aircraft was nicknamed for this flight the Orange Bowl Flyer and was christened with a bottle of orange juice provided by Blue Goose. Indian River oranges from Blue Goose were shipped to New York for the christening celebration. (Published by Tichnor Quality Views; courtesy SMI.)

120

PETITE SHOP. The Petite Shop, located on the corner of Beachland Boulevard and Beachland Drive, was built by owner Dick Bireley. It had a grand-opening celebration on November 1, 1952. Flower arrangements lined the walls for the occasion. The goods, which had been undisclosed prior to the opening, were revealed to be costume jewelry, men's accessories, handbags, and brass and straw goods. Large crowds attended the opening. (Courtesy SMI.)

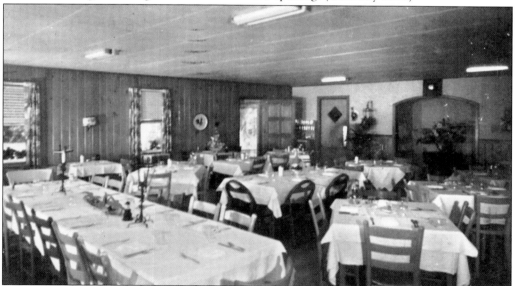

BARRETT'S STEAK HOUSE AND COCKTAIL LOUNGE. Jim and Mary Barrett moved to Vero from Pennsylvania in October 1920. In 1938, they purchased property on U.S. 1 where they maintained a fruit stand and small bar. After World War II, they built Barrett's Steak House on the property. In 1979, it was sold and became Skip Wright's Steak House. It is now the Furniture Man. (Published by O'Brien Color Studios; courtesy SMI.)

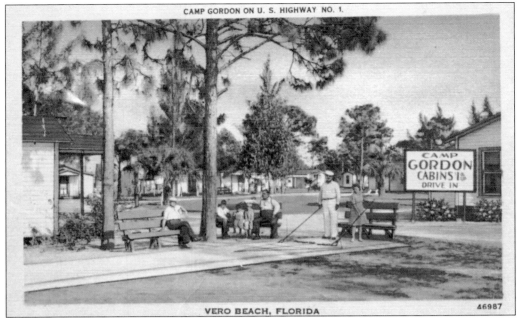

VERO BEACH, FLORIDA 46987

CAMP GORDON. Pioneer Gordon W. Beatty moved to Vero *c.* 1921. Ten years later, he purchased land on U.S. 1 along Thirty-first and Thirty-second Streets, and in 1932, he built Dixie Tourist Camp, which he renamed Camp Gordon. Camp Gordon catered to seasonal residents and groups. The property consisted of one- to four-bedroom cabins. They are now apartments. (Published by L. L. Cook Company; courtesy SMI.)

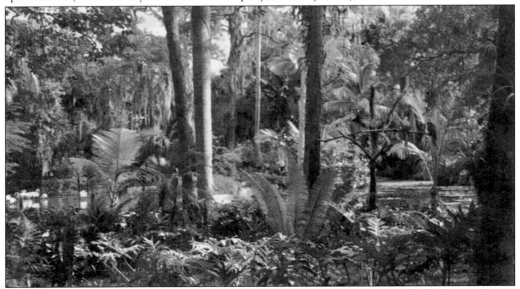

MCKEE JUNGLE GARDENS. In the late 1920s, Arthur McKee started the plans for McKee Jungle Gardens, selecting a piece of hammock land along the Indian River Lagoon south of Vero as the site. William Lyman Phillips, a landscape architect who designed Fairchild Tropical Gardens in Miami, was hired to design the garden. Much of the garden was left untouched to showcase the area's natural beauty. (Published by Colourpicture Publishers; courtesy AC.)

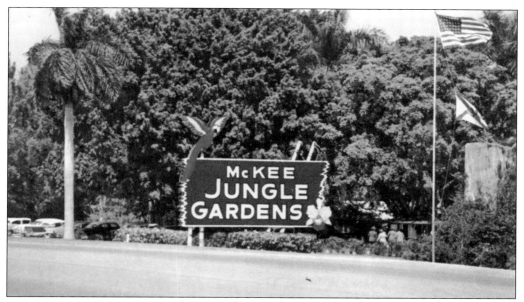

MCKEE JUNGLE GARDENS ENTRANCE. Opening in 1932, the garden was an immediate success. By the mid- to late-1930s, it attracted more than 25,000 visitors annually. McKee worked in concert with the United States Tropical Plant Introduction Center in Miami, receiving many plants from them as part of their experimentation with different plant species. The center introduced hundreds of plants that have since become common in South Florida. (Published by F.E.C. News; courtesy SMI.)

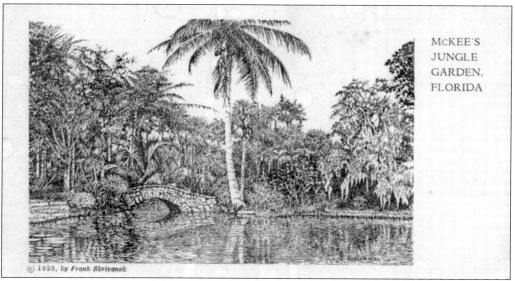

MCKEE'S JUNGLE GARDEN, FLORIDA

© 1936, by Frank Skrivanek

MCKEE JUNGLE GARDENS: BRIDGE. A well of water containing sulphur created the pools, streams, and waterfalls throughout the garden. Tannic acid from the plant life stained it a rich coffee color. In 1946, Dr. David Fairburn was made director. Previously he had been the director of the Missouri Botanical Gardens. The Indian River Land Trust supports the garden, now named McKee Botanical Garden. It is listed in the National Register of Historic Places. (Courtesy SMI.)

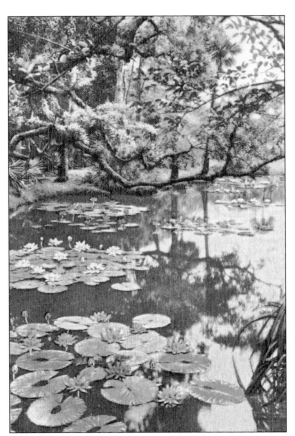

WATER LILIES. More than 40 varieties of water lilies are grown at the garden in a network of waterways that require more than a million gallons of water to be filled. Many of the colored water lilies at McKee Jungle Gardens were developed by Jens Hansen, the McKee botanist. (Published by E. C. Kropp Company; courtesy SMI.)

McKEE JUNGLE GARDENS. By 1940, McKee Jungle Gardens had 100 varieties of hibiscus. Azaleas, gardenias, Spanish moss, air plants, and wild orchids added to the beauty of the gardens. Nearly 100 winter-blooming cattleyas in lavender hues were showcased in the greenhouse and along the many trails. The rows of royal palms were planted by Arthur McKee and Waldo Sexton and became a popular spot to hold weddings. (Published by E. C. Kropp Company; courtesy SMI.)

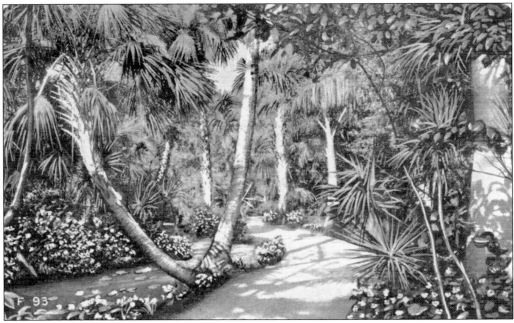

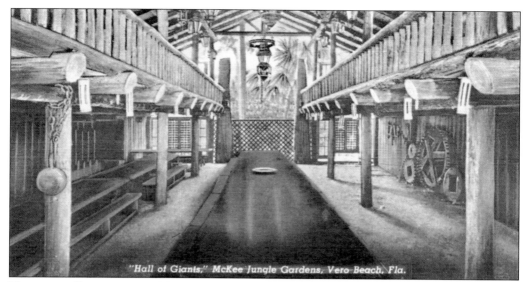

"Hall of Giants," McKee Jungle Gardens, Vero Beach, Fla.

HALL OF GIANTS AND MAHOGANY TABLE. Waldo E. Sexton attended the St. Louis Exposition in 1904, where the world's largest solid mahogany board was displayed—5 feet wide, 5 inches thick, and 35 feet long. In 1940, Sexton bought the board. It was placed in the Hall of Giants at McKee Jungle Gardens, which was constructed to look like a Polynesian ceremonial palace. (Published by F.E.C. News; courtesy SMI.)

HIBISCUS FESTIVAL. Vero Beach is called the Hibiscus City. The original Hibiscus Festival was founded in 1953 and was chaired by the editor of the *Press Journal* newspaper, Harry J. Schultz. When he retired 10 years later, the Queen Pageant ran for an additional year, and the entire festival went dormant until 2004, when Main Street Vero Beach invited Vero Heritage, Inc., and the Indian River County Historical Society to join them in bringing it back to life each October. (Courtesy HS.)

BIBLIOGRAPHY

Gross, George William. *Tales of Waldo E. Sexton, 1885–1967*. Vero Beach, FL: Sexton, Inc., 2001.

Hellier, Walter R. *Indian River: Florida's Treasure Coast*. Coconut Grove, FL: Hurricane House, 1965.

The Indian River Farmer. Chicago: Indian River Farms Company, 1913–1915.

Johnston, Sidney Philip. *A History of Indian River County: A Sense of Place*. Vero Beach, FL: Indian River County Historical Society, 2000.

Lockwood, Charlotte Daniels. *Florida's Historic Indian River County*. Bicentennial ed. Vero Beach, FL: Media Tronics, 1975.

Mimeo News (Wabasso, FL), 1953–[1962?].

More Tales of Sebastian. Sebastian, FL: Sebastian River Area Historical Society, 1992.

Peniston, Dorothy Fitch. *An Island in Time*. New York: Orchid Oaks Books, 1985.

Press Journal (Vero Beach, FL), 1991–present.

Richards, J. Noble. *Florida's Hibiscus City, Vero Beach*. Melbourne, FL: Brevard Graphics, 1968.

Tales of Sebastian. Sebastian, FL: Sebastian River Area Historical Society, 1990.

Thompson, William C. *Pioneer Chit Chat*. Vol. 1 and 2. Sebastian, FL: Sebastian Area County Library, 1987–2004.

Vero Beach, Florida, City Directory. Vol. 1, 1927–1928. Asheville, NC: Florida-Piedmont Directory Company, Publishers, 1927.

Vero Beach Magazine. 1998–present.

Vertical Files. Indian River County History, Archive Center, Indian River County Main Library. Vero Beach, FL.

INDEX